Kiriakos Iosifidis

BIKE ART.
BICYCLES IN ART AROUND THE WORLD

BIKE ART – bicycles in art around the world
Copyright © 2011 Iosifidis Kiriakos & Publikat

First published in 2011 by:
Publikat Verlags-und Handels GmbH & Co. KG
Hauptstraße 204
D - 63814 Mainaschaff
Tel: +49 (0) 60 21 / 900 40 - 0
Fax: +49 (0) 60 21 / 900 40 - 20
info@publikat.de
http://www.publikat.de

Images copyright © 2011 Iosifidis Kiriakos, artists and the photographers,
carpediemact@gmail.com
http://www.carpe-diemact.gr

Editorial: Iosifidis Kiriakos
Design & layout: Same84 (www.same84.com)
Editorial support: Anna Morgenroth
Text editor & translator: Maria Barbatsi
Cover painting by: Pat Perry
Back cover bike art works: Mural by Alex Hornest and bicycle by "Firebikes"

ISBN: 978-3-939566-37-3

All rights reserved. No part of this publication may be reproduced, stored in
any retrieval system or transmitted, in any form or by any means, electronic,
mechanical, photocopying, recording or otherwise, without prior permission in
writing from the publisher.

Printed and bound in China

Kiriakos Iosifidis
BIKE ART.
BICYCLES IN ART AROUND THE WORLD

CONTENT – ΠΕΡΙΕΧΟΜΕΝΑ 003

INTRODUCTION – ΕΙΣΑΓΩΓΗ 004
KIRIAKOS IOSIFIDIS

SUPPORTERS – ΥΠΟΣΤΗΡΙΚΤΕΣ
CARPE DIEM 005
AEROSPOKE 006
PI MOBILITY 007
MBIKE 008
COSMOSLAC – SABOTAZ80 009

URBAN ART 010-011
AEC. INTERSNI KAZKI 012
C215 013
FALKO 014
FUNK25 015
HOPNN 016
NESSE 017
SEX / EL NIÑO DE LAS PINTURA 018
STINKFISH 019
SWOON 020
TIKA 021
MART 022-023

URBAN ART PUZZLE 024-037

PAINTINGS 038-039
ADRIAN LANGKER 040-041
ALISON GAYNE 042-043
BORIS INDRIKOV 044-045
CATHERINE MACKEY 046-047
DARIO PEGORETTI 048-049
ETOE 050-051
HOKE HORNER 052-053
JAMES STRAFFON 054-055
JEFF PARR 056-057
JERRY WAESE 058-059
JIMMY ABROBETS AND BRIAN CHRISTOPHER 060-061
KEVIN NIERMAN 062-063
KO MASUDA 064-067
LINDA APPLE 068-069
LOU READE 070-071
LUMA BESPOKE 072-073
MR KERN 074-075
MWM 076-077
PETER J. KUDLATA 078-079
SHERRI DAHL 080-081
STEVE DENNIS 082-083
TALIAH LEMPERT 084-085
TIAGO DEJERK 086-087

PAINTINGS PUZZLE 088-093

ILLUSTRATIONS – DRAWINGS 094-095
ADAM TURMAN 096-097
ADAMS CARVALHO 098-099
ALAIN DELORME 100-101
ANDY SINGER 102-103
BLANCA GOMEZ 104-105
CHRIS KOELLE 106-107
CHRIS PIASCIK 108-109
CHRIS WATSON 110-111
"COG" 112-113
"CRICKET PRESS" / BRIAN TURNER 114-115
DAMARA KAMINECKI 116-117
DAVID PINTOR 118-119
EMILLIO SANTOYO 120-121
"FIRST FLOOR UNDER" 122-123
FRANCIS KMIECIK 124-125
HUGH D'ANDRADE 126-127
IAN HOFFMAN 128-129
LOVEDUST 130-131
JAMES GULLIVER HANCOCK 132-133
JANET BIKE GIRL 134-135
JAY RYAN 136-137
JENNIFER DAVIS 138-139
JESSICA FINDLEY 140-141
KEN AV DOR 142-143
KRISTA TIMBERLAKE 144-145
MADS BERG 146-147
MIKE GIANT 148-151
MONA CARON 152-153
MONSIEUR QUI 154-155
NATE WILLIAMS 156-157
PAT PERRY 158-159
REMEDIOS 160-161
RICCARDO GUASCO aka RIK 162-163
RUSL 164-165
"SHORTYFATZ" / SAMUEL RODRIGUEZ 166-167
"THE RIDE" 168-169
WILL MANVILLE 170-171

ILLUSTRATIONS – DRAWINGS PUZZLE 172-179

TATTOOS 180-185

SCULPTURES 186-187
ALASDAIR NICOL 188
WILF IUNN 189
CARO 190
MATT CARTWRIGHT 191
DAVID GERSTEIN 192-193
DEREK KINZETT 194
JOE GAGNEPAIN 195
DZINE 196-199
MARK GRIEVE & ILANA SPECTOR 200-201
OLEK 202-203

TYPES 204-205
"AZOR" / KONSANTIN DATZ 206
"BIKE 2.0" / INODA SVEJE 207
"BME DESIGN" / "ONEYBIKE" & "FAJNYJE2" / PETER VARGA 208
BRANO MERES 209
"CARBONWOOD" / GARY GALEGO 210
"ECO//7" 211
"GREEN SHADOW" / JOSE MARIA PARRA 212
"HIDEMAX" / SERVET YUKSEL 213
"HMK 561" / RALF KITTMANN 214
"IBIKE" / REINDY ALLENDRA 215
"KTM X-STREET" / CHARLES EDUARDO 216
"LOCUST" / JOSEF CADEK 217
"NULLA" / BRADFORD WAUCH 218
"OKES" / REINIER KORSTANJE 219
"ORYX" / HARALD CRAMER 220
RAFAEL GEORG SCHMIDT 221
"SANDWICHBIKE" & "DOWNTOWNBIKE" / BLEIJH 222
SCOTT ROBERTSON 223
"SPLIDERBIKE" / MICHAEL THOMPSON 224
"SUITCASE BIKE" / GOSHA GALITSKY 225
TEAM TENTAKULUS / SVEN FISCHER & JENS ROHDENBURG 226
"WALDMEISTER" 227
"ANT WOOD BIKE" & "ANT TRUSS BIKE" / MIKE FLANIGAN 228
"FIREBIKES" 229
"FOX. GAO" 230
"FRETSCHE" / THOMAS NEESER 231
IGOR RAVBAR 232
KEVIN CYR 233
"ORIGINAL SCRAPER BIKES" 234
"STALK BICYCLES" / ZACK JIANC 235
"THE SNOWBOARD BIKE" / MICHAEL KILLIAN 236
VANHU 237
DUANE FLATMO 238-239
KRANK-BOOM-CLANK 240
"WHYMCYCLES" / PETER WM. WAGNER 241

EXTRA 242-243
"CRITICAL MASS": BICYCLING'S DEFIANT CELEBRATION 244-245
"BICYCLE BALLET" 246
"GOODWILL" 247
KARA GINTHER 248
DANIELLE BASKIN 249
"FELVARROM" 250
"MONKEY LED" 251

INFORMATION – ACKNOWLEDGMENTS 252-255
INFO ARTISTS, ORGANIZATIONS & SUPPORTERS
PHOTO INFO
WEB BIKE LINKS

KIRIAKOS IOSIFIDIS

KIRIAKOS IOSIFIDIS

Monocycles, unicycles, tricycles, hand-cycles, touring bikes, folding bikes, race bikes, roadsters, tall bikes, tandem bikes, BMX and freestyle, cruiser bikes, mountain, cross, kinetic, show bikes, trailers, carrier, recumbent bikes, chopper, slider bikes, electric, kids bikes etc., the list is truly endless.

The bicycle, one of the most recognizable and talked about objects of our civilization, it comes from the reminiscence of our childhood.

Being a protagonist of various city movements, the bicycle has already made its mark in the context of various festivals and citizens' actions like "Provos" and the "White Bicycle Plan", "Reclaim the Streets", "Critical Mass", "Bike Film Festival", "Naked Bike Ride", "Bike Music Festival" etc.

Art, from its point, participated too, thanks to Marcel Duchamp and Pablo Picasso, and today, with much more passion and prosperity, thanks to newest artists from illustrators, painters, sculptors, industrial designers to the personal brushworks of anonymous citizens. A cycle of well-known artists and organizations are behind the present book. In this first, collective volume, we classified artists in categories that represent their work. We did this not always with success, since several artists have multiple subjects and mixed techniques. In addition to categories of Murals, Paintings, Illustrations – Drawings, Sculptures, and Tattoos we created a special category, this of Types, in which we included bicycles that have been either designed by companies or by individual designers: bicycles that are prototypes only at designs, prototypes only for presentation, and prototypes ready for production. We also present special types of bicycles that circulate on the roads and at festivals, and they are made by the hobbyhorse and love of inspired riders.

In all this wealth of artistic interventions that you will encounter below are not included the loved categories of custom bikes, hand-made bikes, BMX and freestyle, monocycles, the wide category of outdoor and indoor racing bicycles, the fine art photography, the public bicycles. All this will be the subject of the next album "BIKEART Vol. 2" and you are all welcome to participate!

Like in the "MURAL ART" album, we tried to bring together all those people who dare to support this time the bicycle as means of transport, an idea, and a lifestyle. Those who create and, at the same time, promote the claim for free public spaces, for a viable city.

We believe that the following works will stimulate those who have a bicycle to use it even more, and those who don't get one. Also – and perhaps more importantly – to "awake", as only art can do, the interest inside us for simplicity, contact, dialogue, and the respect for each other.

We hope that, all together, we can push the things for a substantial change of the way we think and live, according to the ideas that bicycles stand for: freedom and the return to nature that surrounds us.

The bicycle, its creators and artists, and the sensitive antennas of our inner world, show us once more the "path". They raise questions. And it's up to all of us if we are able to keep up and open another "cycle".

Have a nice ride!

ΚΥΡΙΑΚΟΣ ΙΩΣΗΦΙΔΗΣ

Monocycles, unicycles, tricycles, hand-cycles, touring bikes, folding bikes, race bikes, roadsters, tall bikes, tandem bikes, bmx και freestyle, cruiser bikes, mountain, cross, kinetic, show bikes, trailers, carrier, recumbent bikes, chopper, slider bikes, electric, kids bikes κ.ά., ο κατάλογος είναι πραγματικά ατέλειωτος.

Το ποδήλατο, ένα από τα πιο αναγνωρίσιμα και πολυσυζητημένα αντικείμενα του πολιτισμού μας, έρχεται από τις μνήμες της παιδικής μας ηλικίας.

Πρωταγωνιστής και των κινημάτων πόλης, το ποδήλατο έχει ήδη δώσει το στίγμα του σε ποικίλα φεστιβάλ και δράσεις πολιτών, όπως το "Πρόβος" και το "Άσπρο Σχέδιο για τα Ποδήλατα", το "Reclaim the Streets", το "Critical Mass", το "Bike Film Festival", το "Naked Bike Ride", το "Bike Music Festival" κ.ά.

Η τέχνη από την πλευρά της συμμετείχε και αυτή χάρη στον Marcel Duchamp και τον Pablo Picasso, και σήμερα, με πολλή μεγαλύτερη ορμή και πλούτο, χάρη στους νεότερους καλλιτέχνες, από τους Illustrators, τους ζωγράφους, τους γλύπτες, τους βιομηχανικούς σχεδιαστές μέχρι και την προσωπική πινελιά ανώνυμων πολιτών. Ένας τέτοιος κύκλος γνωστών καλλιτεχνών αλλά και οργανώσεων είναι αυτοί που στελεχώνουν το παρόν βιβλίο. Σε αυτόν το πρώτο συλλογικό τόμο προσπαθήσαμε να εντάξουμε τους καλλιτέχνες σε κατηγορίες που θα μπορούσαν να αντιπροσωπεύσουν την δουλειά τους και αυτό όχι πάντα με επιτυχία, μιας και αρκετοί καλλιτέχνες έχουν πληθώρα αντικειμένου και μεικτών τεχνικών. Πέρα από τις κατηγορίες των Murals, Paintings, Illustrations-Drawings, Sculptures και Tattoos δημιουργήσαμε μια ιδιαίτερη κατηγορία, αυτή των Types, με ποδήλατα που έχουν σχεδιαστεί είτε από εταιρείες είτε από μεμονωμένους σχεδιαστές: ποδήλατα τα οποία είναι πρωτότυπα και μόνο σε σχέδια, πρωτότυπα αλλά μόνο για παρουσίαση, και πρωτότυπα έτοιμα για παραγωγή. Επίσης παρουσιάζονται εδώ ιδιαίτεροι τύποι ποδηλάτων τα οποία κυκλοφορούν στους δρόμους και σε φεστιβάλ φτιαγμένα από το μεράκι και την αγάπη εμπνευσμένων ποδηλατών.

Σε όλο αυτόν τον πλούτο των εικαστικών παρεμβάσεων που θα συναντήσετε αμέσως παρακάτω δεν συμπεριλαμβάνονται οι αγαπημένες κατηγορίες των custom bikes, των χειροποίητων ποδηλάτων, των bmx και freestyle, των monocycles, η μεγάλη κατηγορία των ποδηλάτων αγώνων σε ανοιχτό και κλειστό χώρο, η εικαστική φωτογραφία, τα public bicycles. Όλα αυτά θα αποτελέσουν αντικείμενο παρουσίασης του επόμενου "BIKEART Vol.2" λευκώματος και σε αυτό είστε όλοι ευπρόσδεκτοι να συμετάσχετε!

Ακολουθώντας το δρόμο που χάραξε το λεύκωμα "MURAL ART", έτσι κι εδώ προσπαθήσαμε να ενώσουμε και να φέρουμε σε επαφή όλους εκείνους τους ανθρώπους οι οποίοι τολμούν να υποστηρίξουν αυτή τη φορά το ποδήλατο ως μέσο, ως ιδέα, ως τρόπο ζωής. Εκείνους οι οποίοι δημιουργούν και ταυτόχρονα προωθούν την υπόθεση της διεκδίκησης ελεύθερων δημόσιων χώρων για μια βιώσιμη πόλη. Πιστεύουμε ότι τα έργα που ακολουθούν θα αποτελέσουν ερέθισμα για όσους έχουν ποδήλατο να το χρησιμοποιούν ακόμη περισσότερο και για όσους δεν έχουν να το αποκτήσουν. Επίσης -ίσως και το σημαντικότερο- να "ξυπνήσουν" μέσα μας, όπως μόνο η τέχνη μπορεί να το κάνει, το ενδιαφέρον για την απλότητα, την επαφή, το διάλογο και τον αλληλοσεβασμό.

Ελπίζουμε όλοι μαζί να ασκήσουμε πίεση για μια ουσιαστική αλλαγή του τρόπου σκέψης και της ζωής μας σύμφωνα με τις ιδέες που εκπέμπει το ποδήλατο: ελευθερία και επιστροφή στους ρυθμούς της φύσης που μας φιλοξενεί.

Το ποδήλατο, οι δημιουργοί του και οι καλλιτέχνες, οι ευαίσθητες κεραίες του έσω μας κόσμου, όλα αυτά μας δείχνουν για μία ακόμη φορά το "δρόμο". Μας βάζουν ερωτήματα. Και εναπόκειται σε όλους μας αν θα συμπορευτούμε και αν θα ανοίξουμε έναν άλλο "κύκλο".

Καλή μας ορθο-πεταλιά!

CARPE DIEM

Dear friends,
Carpe Diem salutes this new effort of Kiriakos Iosifidis, member of our team, about the promotion of alternative forms of civilization, as we believe that bicycle and the ideas that it stands for are.
Since 2000, Carpe Diem has included in its actions the creation of murals and of completed painting programs for the "Car-free Day" and the "European Mobility Week" in cities all over Greece in the context of demands' promotion of free public spaces. In September of 2011, during the "Athens Bike Festival" and in association with the MBIKE magazine, we implement our first "BIKEART" exhibition, including Greek urban artists' work, sculptured constructions in the festival's area and participative actions for the visitors.
So, we welcome you to this panorama of bicycle designs, images, constructions, and the various bicycle types that invite you to think about another way of life which could soon become reality and absolutely workable.

Αγαπητοί φίλοι / ες
Το Carpe Diem χαιρετίζει την καινούργια προσπάθεια του μέλους της ομάδας μας Κυριάκου Ιωσηφίδη για την προώθηση των εναλλακτικών μορφών πολιτισμού όπως πιστεύουμε ότι είναι το ποδήλατο και οι ιδέες που αυτό πρεσβεύει.
Το Carpe Diem έχει εντάξει στις δράσεις του από το 2000 τη δημιουργία τοιχογραφιών και ολοκληρωμένων προγραμμάτων ζωγραφικής για την "Ημέρα Χωρίς Αυτοκίνητο" και την "Ευρωπαϊκή Εβδομάδα Μετακίνησης" σε πόλεις ανά την Ελλάδα στο πλαίσιο της προβολής αιτημάτων για τη διεκδίκηση ελεύθερων δημόσιων χώρων. Τον Σεπτέμβριο του 2011 υλοποιούμε στο πλαίσιο του "AthensBikeFestival" και σε συνεργασία με το περιοδικό MBIKE την πρώτη μας "BIKEART" έκθεση. Η έκθεση περιλαμβάνει έργα ελλήνων urban artists, γλυπτές κατασκευές στο χώρο του φεστιβάλ και συμμετοχικές δράσεις για τους επισκέπτες. Σας καλωσορίζουμε λοιπόν σε αυτό το πανόραμα των ποδηλατικών σχεδίων, των εικόνων, των κατασκευών και των ποικίλων ποδηλατικών τύπων, τα οποία σε παρακινούν σε έναν άλλο τρόπο σκέψης για μια διαφορετική ζωή η οποία μπορεί η γίνει πραγματικότητα και απόλυτα εφαρμόσιμη.

AEROSPOKE

AEROSPOKE
Wheel Performance Technology

"Aerospoke is one of the most recognized and respected names in composite wheels, and has been making them longer than anyone else in the world. We offer aerodynamic wheels for fixed gear bikes, road bikes and racers, mountain bikers, recumbents, and trikes. Aerospoke remains committed to supporting our diverse customers as they each ride on their unique paths to adventure and achievement.

With decades of customer testimonials, several world records and millions of miles ridden on our wheels, our wheel qualities speak for themselves. Our customers continue to trust us because we are dedicated to providing them with wheels that not only look great, but perform well – with the quality, durability, and reliability that you've come to expect from Aerospoke."

PiMOBILITY.

Among the world's finest bike builders, PiMobility stands for integrity, quality, and enduring value. Every PiCycle, is a true "original", built to exacting standards by people dedicated to their work, and to the company they work for. When you take delivery of your PiCycle, you'll do so knowing that no other bike on earth is quite like yours, and no other bike company is quite like PiMobility.

MBIKE: Much more than just a cycling magazine.
The first MBIKE issue came out in spring of 1998 as a bi-monthly cycling magazine that due to its success soon became monthly. MBIKE was quickly established in the emerging cycling market and acted as a pole of development for it as well as an educational tool for the fast increasing number of cyclists in Greece. Keeping close ties with the cycling communities, MBIKE strongly supports the current cycling boom in the local market.

Thirteen years and 95 issues later, MBIKE is the leading monthly cycling magazine in Greece, with very interesting figures: 13 years of national circulation, 10 issues per year, 12,000 print run, 6,000 readers, 800 subscribers, 1,000 copies sold through cycling stores.

Other activities:
MBIKE is much more than just a cycling magazine. It is a whole concept of promoting cycling through different products:

www.mbike.gr: The magazine's website with up to date information and 199,305 visits during the last six months.

WBike: Special bi-annual, free press edition, targeting women, one of the most dynamic and increasing group of cyclists in Greece. Distributed as a free press in 500 locations in Athens, and the greater metropolitan area, with 15,000 copies.

MBIKE Romania: Starting in 2008, MBIKE magazine is being published in Romania as well, with a totally different, Romanian team of editorial staff. It is the only cycling magazine in the Romanian market, leading the trends in Romania as well, a very interesting emerging market.

"Athens Bike Festival": The first "Athens Bike Festival" started in 2010, with more than 15,000 visitors, during the "European Mobility Week", as it became evident that Athens is a city with a growing cycling culture and that an annual cycling festival in the heart of the Greek capital, is a must for the increasing number of cyclists. "Athens Bike Festival" takes place in "Technopolis", an industrial museum of incomparable architecture that has been transformed into a multipurpose cultural space with a special atmosphere that charmed the festival visitors of the first organization.

The event will take place during the "European Mobility Week" – an awareness-raising campaign aiming at sensitizing citizens to the use of public transport, cycling, walking, and at encouraging European cities to promote these means of transport. In 2011, the "European Mobility Week" focuses on alternative mobility and wants to support the transition towards a resource-efficient transport system by promoting clean, fuel-efficient ways, and human-powered travel. Organizers aim at offering visitors the opportunity to see and test the latest bike models, to discuss with the market experts, and to experience, through the parallel activities, an alternative lifestyle that will present them a different and active culture worth to be discovered.

All the major brands of the cycling market are expected to participate in the exhibition part of the festival, making the most out of the opportunity to directly get in touch with the end consumer.

MBIKE: Κάτι παραπάνω από ένα περιοδικό ποδηλάτου.
Το πρώτο τεύχος του MBIKE κυκλοφόρησε την άνοιξη του 1998 ως διμηνιαίο περιοδικό τότε το οποίο σύντομα, λόγω της εξαιρετικά θετικής ανταπόκρισης της αγοράς και των αναγνωστών, έγινε μηνιαίο. Γρήγορα καθιερώθηκε ως το έντυπο της ποδηλατικής αγοράς και λειτούργησε ως ενημερωτικό αλλά και εκπαιδευτικό μέσο για το σύνολο του χώρου, υποστηρίζοντας ταυτόχρονα μέσα από μια σειρά ενεργειών την ανάπτυξη του ποδηλάτου στην Ελλάδα.

Δεκατρία χρόνια και 95 τεύχη αργότερα, το MBIKE παραμένει το κορυφαίο, μηνιαίο ποδηλατικό περιοδικό στην Ελλάδα, έχοντας να παρουσιάσει ιδιαίτερα ενδιαφέροντα στοιχεία όπως: 13 χρόνια συνεχούς πανελλαδικής κυκλοφορίας, 10 τεύχη το χρόνο, 12.000 τεύχη τιράζ, 6.000 αναγνώστες, 800 συνδρομητές, ενώ 1.000 τεύχη πωλούνται απευθείας σε ποδηλατικά καταστήματα.

Άλλες δραστηριότητες:
Το MBIKE είναι κάτι παραπάνω από ένα ποδηλατικό περιοδικό, είναι ένα ολοκληρωμένο concept για την προώθηση της ποδηλασίας στην Ελλάδα, μέσα από διαφορετικά προϊόντα.

www.mbike.gr: Πρόκειται για το web site του περιοδικού, με συνεχή, καθημερινή ανανέωση και περισσότερους από 199.000 επισκέπτες τους τελευταίους 6 μήνες.

Wbike: Ένα ειδικό, free press περιοδικό που κυκλοφορεί 2 φορές το χρόνο ειδικά για γυναίκες, το ταχύτερα αναπτυσσόμενο αυτή τη στιγμή κοινό στην Ελλάδα. Διανέμεται δωρεάν σε 500 επιλεγμένα σημεία στην Αθήνα και στην ευρύτερη περιοχή της πρωτεύουσας, σε 15.000 αντίτυπα.

MBIKE Romania: Από το 2008, το MBIKE κυκλοφορεί και στην αγορά της Ρουμανίας, μέσα από μια διαφορετική συντακτική ομάδα, από ρουμάνους δημοσιογράφους και στελέχη. Είναι το μόνο περιοδικό για την ποδηλασία στη χώρα και οδηγεί τις εξελίξεις σε μια ιδιαίτερα ενδιαφέρουσα, ανοδική αγορά.

"Athens Bike Festival": Ξεκίνησε το 2010, με περισσότερους από 15.000 επισκέπτες, στο πλαίσιο της "Εβδομάδας Εναλλακτικής Μετακίνησης", καθώς είναι γεγονός πως η Αθήνα είναι μια πόλη με αναπτυσσόμενη ποδηλατική κουλτούρα. Το "Athens Bike Festival" πραγματοποιείται στις εγκαταστάσεις της "Τεχνόπολις" και συγκεντρώνει το ενδιαφέρον τόσο των καταναλωτών όσο και των επαγγελματιών της αγοράς του ποδηλάτου. Πρόκειται για ένα γεγονός που σηματοδοτεί την ανάπτυξη της χρήσης του ποδηλάτου στη χώρα μας και δίνει την ευκαιρία σε όλους να γνωρίσουν από κοντά τα νέα μοντέλα, τις εξελίξεις αλλά και τις τάσεις της αγοράς.

Παράλληλα, στο πλαίσιο του "Athens Bike Festival", υλοποιούνται μια σειρά από δράσεις που στόχο έχουν να ευαισθητοποιήσουν το κοινό απέναντι στο ποδήλατο, αλλά και να δείξουν τη δυναμική του χώρου. Από καλλιτεχνικά δρώμενα έως αθλητικές επιδείξεις και βόλτες στο κέντρο της πόλης, η Αθήνα ζει για το ποδήλατο για τρεις ημέρες το χρόνο, με στόχο να δοθεί έτσι το μήνυμα ώστε η πόλη ν' αρχίσει να ζει με το ποδήλατο.

COSMOS LAC - SABOTAZ80

That's enough.
My public space is neither in need of self-appointed advocates nor academic approaches. For decades now, I have been inhabiting and traversing it, and I am being hunted down to a state of total intellectual and material impoverishment. And I am being stowed away, and thrown about, and hustled in public view. My public space does not need beautification and verbal reconstructions. It is dyslectic, disturbed and unbearably ugly. It is which it has been left at its own devices to become. Along with it, myself. As for you, I want you to tell me something new. Or at least something old, but in your own way. I want to see you, at last, assuming your personal responsibility. Not so much to any others, but to yourself alone. I wish at some point to find consistency in your actions and your feelings, as well as between those two. I want to gain courage from you, myself. Creator or viewer, whoever you are, tell me: Who are you? Take the risk of revealing your truth, even if only partially. Express yourself and don't be afraid. Who deprived you of the hope of this redemption? Do not underestimate my intelligence and don't forejudge my intentions. Benumbed in this phantasmagoria, with fragmented identities and consciences, we experience our subjective reality while being cut off from the social milieu. Let's make an effort to reclaim our humanity together, our agency on our environment and ourselves.

And this rarely happens in a financially compensating, aesthetically pleasing or safe manner. We will have to take a risk in communicating. And this communication will lie beyond the logic of markets, any kind of central political planning or elitism. This communication does not bear the seal of approval of corporate "others": product and spectacle industries, art collectives, sponsorships, advertising, centrally planned artistic interventions and all the indicated politically "correct" ways of expression. It is dirty and costly, both in time and money, and will not turn you into a celebrity. It will, however, leave you with a smile in the end of the day and an inexhaustible sensation of fulfillment of a deeper duty. That's why I only want to remind you that the city belongs to you. In the nights, if you'd walk it, you would hear it pleading you to touch it, even briefly, in the dark. To love it hastily, there and then, standing against a wall.

And don't forget. This is just an opinion, not an axiom of any kind. Do not identify with anything. You have an obligation to search truth on your own.

Joanna, Achilles, Vasilis, Tasos

Αρκετά.
Ο δικός μου δημόσιος χώρος δεν χρειάζεται αυτόκλητους συνηγόρους κι ακαδημαϊκές προσεγγίσεις. Δεκαετίες τώρα, κατοικώ μέσα σε αυτόν και κινούμαι, και καταδιώκομαι προς μια κατάσταση ολικής πνευματικής και υλικής πτώχευσης. Και στοιβάζομαι και ξεβράζομαι και βιάζομαι σε κοινή θέα. Ο δικός μου δημόσιος χώρος δεν χρειάζεται καλλωπισμό και λεκτικές αναπλάσεις. Είναι δυσλεκτικός, διαταραγμένος κι αβάσταχτα άσχημος. Είναι αυτός που αφέθηκε να γίνει. Μαζί μ' αυτόν κι εγώ. Όσο για σένα, θέλω να μου πεις κάτι καινούριο. Ή έστω κάτι παλιό, αλλά με το δικό σου τρόπο. Να σε δω να αναλαμβάνεις επιτέλους τις ευθύνες σου. Όχι τόσο απέναντι στους άλλους, όσο απέναντι στον εαυτό σου τον ίδιο. Θέλω κάποια στιγμή να υπάρξει συνέπεια στις πράξεις και τα αισθήματά σου, κι ανάμεσά τους. Θέλω να πάρω θάρρος από σένα κι εγώ. Δημιουργός ή θεατής, όποιος κι αν είσαι, πες μου: Ποιος είσαι; Διακινδύνευσε να δείξεις την αλήθεια σου, έστω και μισή. Εκφράσου και μη φοβάσαι. Ποιος σου στέρησε την ελπίδα αυτής της λύτρωσης; Μην υποτιμάς τη νοημοσύνη μου και μην προδικάζεις τις προθέσεις μου. Μουδιασμένοι σε αυτή τη φαντασμαγορία, με κατακερματισμένες ταυτότητες και συνειδήσεις, βιώνουμε την υποκειμενική μας πραγματικότητα αποκομμένοι από το κοινωνικό σύνολο. Ασκάνουμε μια απόπειρα μαζί να διεκδικήσουμε πίσω την ανθρωπιά μας, την αυτενέργειά μας πάνω στο περιβάλλον και τον εαυτό μας. Κι αυτό δεν γίνεται σχεδόν ποτέ με οικονομικά ανταποδοτικό, αισθητικά ευχάριστο και ασφαλή τρόπο. Θα πρέπει να διακινδυνεύσουμε να επικοινωνήσουμε. Κι αυτή η επικοινωνία βρίσκεται πέρα και πάνω από τη λογική της αγοράς και κάθε είδος πολιτικού σχεδιασμού ή ελιτισμού. Αυτή η επικοινωνία δεν φέρει την έγκριση εταιρικών «άλλων»: βιομηχανιών προϊόντων και θεάματος, καλλιτεχνικών κολεκτίβων, χορηγιών, διαφημίσεων, κεντρικά σχεδιασμένων καλλιτεχνικών παρεμβάσεων και όλων των ενδεικνυόμενων πολιτικά «ορθών» τρόπων έκφρασης. Είναι βρόμικη και κοστίζει σε χρόνο και χρήμα και δεν θα σε κάνει διάσημο. Θα σε αφήσει όμως με ένα χαμόγελο στο τέλος της ημέρας και μια αστείρευτη αίσθηση εκπλήρωσης ενός βαθύτερου καθήκοντος. Γι αυτό θέλω μόνο να σου θυμίσω πως η πόλη σου ανήκει. Τις νύχτες, αν την περπατούσες, θα την άκουγες να εκλιπαρεί να την αγγίξεις έστω και λίγο στα σκοτεινά. Να την αγαπήσεις βιαστικά, εδώ και τώρα, όρθιος στον τοίχο. Και μην ξεχνάς. Αυτά είναι απλά μια γνώμη, όχι αξιώματα. Μην ταυτίζεσαι με τίποτα. Έχεις υποχρέωση να ψάξεις την πραγματικότητα μόνος σου.

Ιωάννα, Αχιλλέας, Βασίλης, Τάσος

2 URBAN ART.

On the following pages we present you bicycle art work by muralists, painted on different surfaces and with the use of different techniques such as spray, acrylic, stencil etc.

2 AEC. INTERESNI KAZKI.

AEC (Aleksei Bordusov) and Waone (Wladimir Manzhos) are two precursors of graffiti in Eastern Europe. Both grew up in Kiev, Ukraine, where they developed their art among the collective "IK", which they created in 1999. At first, these initials corresponded to "Ingenuous Kids", a crew of 11 friends who practiced graffiti. As their art evolved over the years, in 2005 the two friends continued their passion under the name of "Interesni Kazki" (that we can translate as "interesting tale") in order to slowly break with traditional graffiti codes. They stood out, for example, by excluding lettering from their paintings in order to represent fantastic and surrealistic characters. This new art bears a certain relationship to the South American muralism movement, whose practice consists of painting murals with political content over the walls of cities, especially on public buildings.

They usually work together, which allows them to be better organized, and therefore even more efficient. They also use very large areas such as entire building facades, a dozen of which have already been completed in Kiev, as well as more than 50 other paintings all over Ukraine.

All these paintings share the fantastic sphere proper to Interesni Kazki representing the imagery of fairy tales, magic, space, mysticism, science, and religion. This world of living objects, symbols, and magical beings is an "all-embracing image of the universe" which denies the ordinary and senselessness. Through this paradoxical universe the two artists wish to represent reality the way they perceive it and in turn allow the spectator to discover his or her own respective reality.

Photo portrait: "Infinity". Artist: Aleksei Bordusov (AEC. Interesni Kazki). Canvas, 2009
01 & 02: Artist: Aleksei Bordusov (AEC. Interesni Kazki), Kiev / Ukraine, 2009

C215, real name Christian Guémy, is a French street artist hailing from Paris. C215 primarily uses stencils to produce his art, and his work consists mainly of close-up portraits of people. His subjects are typically those such as beggars, homeless people, refugees, street kids, and the elderly. The rationale behind this choice of subject is to draw attention to those that society has forgotten about. C215 is a prolific street artist and has practiced his art in cities all over the world. His stencils may be seen in Barcelona, Amsterdam, London, Rome, and of course Paris.

In addition to his street work, C215 also produces commercial art work for galleries on wood and canvas. C215 has to date done a number of solo gallery shows to promote his work.

from Wikipedia

2 FALKO.

In South Africa, Falko is a grafiti icon, not only for his style, but also for establishing graffiti as a credible visual art form, and for creating a platform for aspiring writers. After 22 years as a graffiti artist, Falko is widely regarded as an integral part of the foundation and development of South Africa's graffiti scene.

- drinks coffee
- writes graffiti
- lives in Hamburg
- likes painting
- eats fish
- cuts stencils
- sits in the sun
- loves bikes
- is on holidays
- runs a gallery
- turns the music on
- lives in a squat
- has to clean his place
- so stop that ****shit here ...

2HOPNN.

"I live and work in Rome. I love to paint bikes around the city like a manifesto to promote the use of bicycles in town. My motto is: + B.C. = - CO$_2$."

"Colours, style, and bicycle, that's the best way to feel free! Dirty hands with paint and grease are synonymous with a good day! No gasoline, only good beer, no toxic smokes, only sweats! My renovated grandfather trailer is a faithful fellow traveller for the largest scales of mural painting; I can find everything I need! Follow that Rasta van migration and you will find the power of creation."

01: Farmers shop, l' Ecancières / France, 2011
02: Old "Grand'Bi" at "Un P'tit Vélo Dans La Tête" bicycle association, Grenoble / France, 2009
03: "Bicycle Highway". Together with Ame. Grenoble / France, 2009

2 SEX/EL NIÑO DE LAS PINTURAS.

"I am 'Sex/El Niño de Las Pinturas', a painter since I was a kid ... the addiction to the solvent will start soon, and until now I haven't been able to overcome it and ... the smell of paint and colour vibration transport it without moving ... through contact with multiple shamans of the same trade, I am considered a student, hopefully for life ... if the world is dark ... light your part ..."

01: "Furgoneta de Transporte Infantil". Granada / Spain, 2007
02: Granada / Spain, 2004
03: "El Color de la Calle II. El Arte se Mueve". Granada / Spain, 2009
04: "Para 'techari' (ojos de brujo)", 2005

2STINKFISH.

"I live in Bogotá since 1985 when my parents returned to Colombia after their passage through Mexico. Since I could do it, I started to walk back and forth the city without a fixed course, especially in the centre and its surroundings. I found all kinds of people, places and images. I think all these experiences led me to paint the walls of the street, not only the ones of my house."

01: Cali / Colombia, 2010
02: Guatemala City / Guatemala, 2009
03: Barcelona / Spain, 2008

2SWOON

Swoon is a Brooklyn-based artist whose life-sized woodblock and cut-paper portraits hang on walls in various states of decay in cities around the world. She has designed and built several large-scale installations, most notably the "Swimming Cities of Switchback Sea" at "Deitch Projects" in 2008. Swoon has been travelling for the past several years creating exhibitions and workshops in the U.S.A. and abroad. Swoon is also an instigator and a collaborator. She founded the "Toyshop Collective", and the "Miss Rockaway Armada", and is a member of "Justseeds" and the "Transformazium".

Her artistic process is predicated on the belief that art is an immersive, provocative, and transformative experience for its participants. Although Swoon's aesthetics can be seen as an outgrowth of street art, her engagement with ethical living and making art shares a close kinship with the idealism of off-grid, barter-based cultures and economies based on sharing. She uses scavenged and local materials and embraces print media as a potent means of action for social change.

01 & 03: "Bicycle Boy"
02: "Argentina"

TIKA.

TIKA is a global nomad whose central concern is the nearly forgotten history, currently ensnarled circumstances and the volatility of existence. Having lived in cities such as Zürich, Berlin, Rio de Janeiro, Cologne, and Cairo, and during her longer stays in Cape Town, New York, and Mexico City, TIKA was introduced to eclectic cultures, societies and traditions. She has been drawing ever since. After pasting up hand-drawn circus-posters at the age of eight, she got introduced to graffiti while she was working as a bike messenger in the late '90s. Because of all these influences, the interest in myth and symbolism, inputs of everyday life and her current surrounding, she creates graphically reduced imagery filled with painted, scratched, burned textures, and traditionally inspired patterns, always experimenting with new materials and techniques.

01: "Tandem Velove".
Collaboration with Bera White. Lodi / Italy, 2010
02: "Papergirl 5". Berlin / Germany, 2010
03: "Stadtmusikanten".
Collaboration with Kowalski. Istanbul / Turkey, 2011

2MART.

Graffiti first came to Mart's life in 1998 in the neighbourhood of Palermo, Buenos Aires, at the age of 11, when he enrolled in the 6th grade of elementary school, and he was with his teachers and friends of the DSR crew.

He develops light, shifting, and long strokes. His characteristics are the full colour and a series of stylized characters from a world with aspiration for calm and peace everyday.

He currently lives in Palermo, where his entire work can be seen.

2 URBAN ART PUZZLE.

01: Artists: Besok & Rookie. Muenster / Germany, 2004
02: "Bx Bike". Artist: Cern
03: Artists: Tika & Lelo. Bike Film Festival "Inoperable"
04: "Tandom Bikes". Artists: Drypnz in collaboration with PNTR
05: "Andy Rides". Artists: Drypnz in collaboration with PNTR
06: Artist: Jamer. Komotini / Greece, 2010

01: "Cyclo". Artist: Sebastian James
02: "No Bikes Here". Artist: Alex Hornest. Vienna / Austria, 2010
03: "Geometricismo". Artist: Andruchak. Vila de Ponta Negra, Natal / Brazil, 2011
04: "Cycloman". Artist: Sebastian James
05: "Beco Rato". Artist: Ciro Schu
06: Artist: Liqen. Mural detail. Guadalajara / Mexico, 2011

01: Artists: Zonenkinder. Project "StadtRAD Hamburg – On Your Mobile Canvas and off You Go!", ⓘ
02: Artist: Ryan Dineen
03: Artists: Sabotaje Al Montaje. Barcelona / Spain, 2010
04: "La Entrada Wall 3". Artists: Werc & Crol. California / USA, 2009. Photo © Geraldine Lozano
05: "The Duboce Bikeway Mural". Artists: Mona Caron, J. Gordon Dean, Mary Anderson, Seth Damm, Bill Stender & Michael Rousseau. Photo © Lars Howlett, ⓘ
06: "Ride Your Bicycle for Free Parking". Artist: Peter Drew. Adelaide / Australia, 2011. Photo © Mark Zed

01: Artist: Lundo
02: Artist: Pener
03: Artists: Vitche & Jana Joana.
Lueneburg / Germany, 2009

01: "The Meeting (Summer)". Artist: David Guinn. Mural detail. Philadelphia / USA, 2001
02: Artist: Besok. Volos / Greece, 2002
03: "La Boca 1". Artist: Gualicho
04: Artists: Extralargos
05: Artists: Live2 & Apset. Volos / Greece, 2010
06: Artist: Woozy. Athens / Greece, 2009
07: Artist: Jamer. Athens / Greece, 2010

01: "Bike Smoka".
Artist: Ciscoksl, 2009
02: Artist: Zbiok.
Valencia / Spain, 2011
03: Artist: Bill Wrigley. Ryerson University, Toronto / Canada, 2008
04: Artist: Paul Santoleri. Sponsored by "Mural Arts Program Philadelphia".
Photo © Lu Szumskyj
05: Mural detail. Artists: Mandy Van Leeuwen & Michel Saint Hilaire. Daly Burgers, Winnipeg / Canada, 2009

35

01: Artist: Kenor
02: Artist: Erik Burke
03: "Surfbike". Artist: Dave Loewenstein
04: "Wrong House". Artist: Dave Loewenstein
05: Artists: Os Gemeos. Athens / Greece, 2005
06: Artists: 3Steps
07: "Lend Me Your Ears". Artist: Jordan Monahan. "Sprout Public Art", Pittsburgh / USA, 2004
08: Artists: Siche, Katre, Baske & Twopy. Paris / France, 2006

37

3 PAINTINGS.

On the following pages we present you bicycle art work by painters, painted on different surfaces and with the use of different materials. In this category, we also include the paintings on bicycles.

3 ADRIAN LANGKER.

Adrian is an Australian painter who has been commuting by bicycle for over 20 years. During this time he has witnessed the slow transformation of attitudes towards cycling from the belief that the cyclist has no place on the road to the acceptance by many of cycling as a popular form of transport. In Australia bicycle sales have increased by 67% since 2001.

His home, the City of Sydney, has the perfect climate for cycling. The biggest impediment to more people cycling is not the distances or hills but the lack of cycle paths and the attitude of some drivers in their life-size "Hot Wheels" cars. Realizing this, the City of Sydney Council has been busy building cycle ways. In car worshipping Sydney this must be fully appreciated as a bold and visionary move. It represents a major generational shift in attitude. Predictably, the echo chambers of talk-back radio and the conservative press have aggressively attacked the council, often dangerously encouraging the malevolent attitude of some drivers towards cyclists.

Adrian views his paintings as an incremental antidote to the noisy "cars only" orthodoxy and as a "thank you" to the council for having the courage to build cycle ways.

01: "Bicycle Smile". Acrylic on canvas, 2010
02: "Bike Parts". Acrylic on canvas, 2008
03: "Green Machine". Acrylic on canvas, 2010
04: "Bike Envy". Acrylic on canvas, 2008
05: "Brakes on Blue". Acrylic on canvas, 2010

3 ALISON GAYNE.

"My work tries to catch fragments of the past and share those displaced memories through images. I intentionally used a minimum of colours to symbolize the eternal nature of these moments in time. The objects and actions in the work depict moments of play which represent dreams and aspiration often connected with childhood.

After a lecture by Phillip Glass, I was inspired by what he said about the role of the artist; the vocation of the artist is to bring magic into the mundane life. My work has always been about an attempt to bridge life's mysteries with material truths. The pieces here represent a nostalgic exploration that revisits the mundane moments of childhood and instils a lost, mystical quality to them.

Art in its purest form derives from an intuitive process, and as an artist what I choose to express is channelled from something larger than myself as an individual. The process of making art takes on a deep, visceral, and profound manifestation that evolves beyond ego, the artist, or anything that can be categorized. My work is a continued attempt to bridge life's mysteries with material truths."

01: "I Thought of That While Riding My Bicycle"
02: "Get a Bicycle. You Will Never Regret It. If You Live"
03: "Especially in the World of Bicycling, What Goes Around Comes Around"
04: "The Bicycle, the Bicycle Surely, Should Always be the Vehicle of Novelists and Poets"
05: "Nothing Compares to the Simple Pleasure of a Bike Ride"
06: "It Never Gets Easier, You Just Go Faster"

43

3 BORIS INDRIKOV.

"Reinventing the wheel as a way of exploring the world". A saying goes: "New is a well forgotten old". The project "Great Bikes" ("Velikie Veliki") is an attempt to turn old into new and to remind us today of the forgotten past. Universally recognized masterpieces begin a new life, bringing artists from the depth of the centuries closer to our time. Nothing that was created by great masters disappears. Everything is here and now, everything stays with people. One just needs to look deeper into the surrounding world and, as often as possible, to reinvent the wheel ..."

Boris Indrikov was born in Leningrad in 1967 and lives and works in Moscow. From 1991 to 1997 he was a book designer and worked as an illustrator for the popular science magazine "Chemistry and Life". He has been a member of the "Creative Union of Artists of Russia" and the "Unesco International Federation of Artists" since 1998. He has exhibited works in a number of shows in Russia and abroad ["Art-Manezh" 2002, 2003, "Drömmar" (Sweden, Nyköping, 2004) and others]. He currently works in painting, graphic design, and small-form plastic. He works mainly in fantastic realism. His pictures are in the "Horizon" gallery (Netherlands), and private collections in Russia, Sweden, Germany, France, Switzerland, Japan, and U.S.A.

01: "Gogen". Detail
02: "Gogen"
03: "Van Eyck"
04: "Richard"
05: "Henry"

Velikie Veliki

HENRY VIII

3 CATHERINE MACKEY.

"My work is about the urban experience. I study the old and industrial buildings I discover in the cities I visit. The utilitarian architectural style employed in these buildings is simple and honest. Their story is told by the accumulation of paint, sign writing, posters, and graffiti. The beauty which results from these layers of history is unintentional and surprising.

This visual honesty and simplicity extends to the smaller scale artifacts of the urban environment: fire hydrants, hand-painted signs, public phones, and bicycles – all of these I have featured in my work.

On my walks around neighbourhoods looking for urban 'glimpses' to include in my paintings I began to notice that bicycles were everywhere. Bicycles outside every coffee shop and on every corner – new and old, sleek and hand-painted, flashy and customized. I realized that, if my paintings were to convey the urban environment, there had to be more bicycles!

I cleared my studio, borrowed bicycles from friends, and started to draw. I spent months working on bicycle drawings and paintings. The paintings incorporate the same techniques of collage, stencils, and text which can be found in my urban paintings. During the process I had a great deal of fun and have learned a lot about how these beautiful machines are built. Now I seek out bicycles whenever I am out on one of my 'urban explorations'."

01: "Cruiser # 6". Charcoal on paper, 2010
02: "Limited # 5". Charcoal on paper, 2010
03: "Cruiser # 4". Mixed media on wood, 2010

01: "Cruiser # 3". Mixed media on wood, 2010
02: "Limited # 1". Mixed media on wood, 2010
03: "OS Bike # 2". Mixed media on wood, 2010
04: "Cruiser # 1". Mixed media on wood, 2010

3 DARIO PEGORETTI.

Dario Pegoretti (18/01/56) is a framebuilder from Northern Italy. He started as an apprentice in the workshop of Luigi Milani in the 1970s and by the age of 35 he became craftsman, well credited around the world. His long pathway passed from the Milani workshop to his own, where the production runs up to 300 frames a year. Regarding the models, there are uncommon designs on every detail from both technical and aesthetic point of view. Pegoretti has always been interested in new things and the courage to be unique, but time has shown that this is his secret of success. There is always a certain will to have or copy his chainstay and dropout designs, because aside of function they became his trademark. After that, he developed an over-oversize lugset with Darrel McCoullogh, and nowadays he is busy to realize his own carbon fork (designed to match the new headset standard as a co-operation with Chris King). His idea about bicycles is giving a great impression on cyclists both with perfomance and appearance as well as with uncommon design solutions.

Daniel Merenyi

01: "Conn"
02: "Guantanamo"
03: "Catch The Spider"
04: "Manovella"
05: "Panel"

49

3 ETOE.

Etoe is a German design agency which was established by Martin Jahnecke in 2007. The name Etoe stands for "end to end", a term used in the graffiti scene. Etoe is specialized on bike designs and offers extraordinary designs as well as hand-made masterpieces, especially on bike frames.

Martin Jahnecke, who is the creative head of the company, started his artistic career when he was only 15 years old. He mostly worked in the area of airbrushing and photorealism. During his course of studies to become a communication designer, he decided to found his own design agency focussing on the bike industry. Etoe develops digital design concept studies for bicycle manufacturers, hand-made unique items, whose production can take more than 100 hours, as well as custom-built models for collectors and bike enthusiasts. Etoe produces and paints all designs in-house. The most popular models are theme bikes like the "Sidewalkkiller" or "Money Jack" whose paint displays topics like "Heaven and Hell", "Apocalypse" or "Las Vegas" with its casinos, gambling and table dancers. Etoe paints all his designs on frames made of aluminium, steel or titanium as well as on high tech racing bicycles made of carbon. The motto is "In Colour We Trust". That means that not only the designs are sketched from end to end but also one of a kind bikes are hand-painted in unique styles.

01-03: "Handbike"
04-08: "Money Jack"

3 HOKE HORNER.

Working in her studio one summer evoked images that evolved to the "Birds and Bikes" series. Having a very healthy collection of bicycles parked in her studio, inspired the artist to an exploration of colour and texture within the canvas. Being an avid fan of travel, Hoke Horner often feels that simply getting on a bicycle and making the decision to go can be as freeing as taking a trip thousands of miles away. Hoke Horner has a B.A. in painting and lives in Oregon with her husband Jory and their scruffy dog Stella.

01: "Caged Bike"
02: "My Bicycle, How Perfect My Bicycle"
03: "Talkin' Talkin'"
04: "Sister Had a Basket"
05: "Out For a Ride"

3 JAMES STRAFFON.

James Straffon lives and works in London. He has exhibited with Paul Smith at "The London Art Fair".

01: "Divertimenti", 2011
02: "Condor Mackeson Purple", 2010
03: "Il Padrone", 2011
04: "King of the Mountains", 2010
05: "Bobet Départ", 2011

"Broadly speaking, the subject, and focus of my paintings and mixed-media collages is the bicycle. Specifically my emphasis is on heritage; being present in classic calligraphy, period palette or photo-montaged moments in time. This and a pop-art approach to capturing the multi-faceted legacy of the bike provide the impetus for my work.

In the process, I have championed the ethos of Marcel Duchamp – in his belief that an ordinary object can be elevated to the dignity of a work of art by the mere choice of an artist.

Here, my own choice of muse – the mythology of bicycle culture – is what draws my eye. This passion for cycling fused with an equal aspiration to produce artworks of visual intrigue and appeal, provide the ingredients for my creativity. The artworks I compose incorporate the culturally-rich narrative of road racing, reworked to tell the stories of yesteryear, within a new and modern framework."

3 JEFF PARR.

Jeff Parr (born in 1947) is a British artist now living permanently in Savoie, France. After graduation, he worked as a freelance fine artist on productions with the "Royal Shakespeare Company", the "Royal Opera House", "Madame Tussauds" the "London Planetarium", and the original London stage musical, "Evita".

As an animator and graphic designer with Yorkshire Television, Jeff won many awards including the prestigious "International Paragraph Network Identity Grand Prix" (Paris) and the "Best Graphic Design" honour of the "International Visual Communications Association".

Throughout his professional career, Jeff's passion has always been the bicycle and now, living amongst the legendary Alps where the bicycle is king, he is able to devote himself to full-time painting. His emotions are portrayed so vividly in his paintings depicting the legends, the passion, the evocative sensations and also homage to the greats of professional cycling over the decades. He invites the viewers in to his paintings without necessarily making it easy for them.

01. "C.H.U.T.E" (Cycling History's Ultimate Triumph Evaporates). Acrylic on canvas, 2008-09
02. "Ultimo Giro". Acrylic on linen, 2009
03. Self-portrait collage with "Mondrian was Right". Oil on canvas, 2005
04. "Venice in Pink". Acrylic on linen, 2010

3 JERRY WAESE

"As a minimalist, I like a simple uncluttered approach to everything and yet I like to leave everything messed up in an inviting way. Bikes are a great topic for me because they are simple machines that deliver mind boggling experiences; often they are as colourful as butterflies, flowers or birds.

Some people say I am a better teacher or commentator than an artist, so that probably means they must have learned something and while this is great, I have no intention of teaching in all things. I am a beginner, just out of training wheels you could say. In the last few years I have rediscovered crayons, no ordinary crayons, but no magic crayons either. The rediscovery is like magic. My original passion 50 years ago was just a simple black crayon."

01: "Red and Tethered". Detail. Black ball pen, neocolour II water soluble wax crayon, white oil pastel in sketchbook, 2009
02: "At Ossington". Black ball pen, neocolour II water soluble wax crayon, in sketchbook, 2009
03: "Bike Walkers". Black ball pen, neocolour II water soluble wax crayon, copic marker in sketchbook, 2008
04: "Chinese Cyclists in Paris". Acrylic on canvas. The 36th out of 40 Acrylic works done for "The 30 Day Artist Project", 2005
05: "That Girl Across the Street". Black ball pen, neocolour II water soluble wax crayon, in sketchbook, 2009

3 JIMMY APROBERTS AND BRIAN CHRISTOPHER.

It's late Friday afternoon, just seven days away from an upcoming art show. As usual, Jimmy and Brian have nothing ready. This is what they do; they thrive on the stress and panic of deadlines. So they decide to procrastinate some more and let the weekend decide their fate. Monday brings new hope. Beside Brian's desk lie three new abstract landscapes that Jimmy painted over the weekend. All three are on long, horizontal wood panels, but they have deliciously different textures and colours. These abstract beauties are ready to hang, except for one thing. The art show has a theme – bicycles. There are no bikes to be found.

One thing is agreed – the paintings need to appear as abstract landscapes. The rest is left to Brian, who was already thinking about some of the strange bike events witnessed in San Luis Obispo. Memories of bike battles secretly held under cover of darkness – wheels slamming, chicken drumsticks flying, losers, pounding asphalt – not to mention swarms of maniacal cyclists in costumes flooding the streets of downtown each month with diapers, moustaches, tin cans, prom dresses, wigs, bathrobes, ghetto blasters, tall bikes, and sofas on wheels. From this, the bubble heads emerge – awkward, goofy, determined, confused, and playful. The first three paintings became unicycles, tandems and tricycles. And they made it to the art show on time … barely.

JA/BC Studio. *"A Moment of Desperation"*. San Luis Obispo, May 2007

01 & 03: "50 Points"
02 & 04: "Guitar Solo"
05: "1.21 Gigawatts"
06: "The Accidentals"

3 KEVIN NIERMAN

Kevin grew up in rural Missouri (USA) back in the 1970s. His first bike was a second-hand, banana-seated Schwinn Stingray knock-off that he got for his fifth birthday. Not quite suited for the gravel country roads, his father modified it with knobby tires, BMX grips, and fresh paint to create the coolest mini klunker any kid could have. That was the catalyst for Kevin's obsession with these two-wheeled machines and it has carried over into his art work. He regularly contributes his visions to "Dirt Rag" and "Bicycle Times" magazines, but by day he finds humorous irony playing art director for a national dairy trade publication despite having an extreme allergy to dairy products. His two young children just learned to ride, so he enjoys exploring the neighbourhoods with them and his lovely wife, racing road and mountain bikes, commuting and simply hopping on a bicycle and wandering around some of those old gravel roads he grew up on. He hopes his art evokes some of that same childhood joy that riding a bicycle does.

01: "Evolution". Mixed media on board, 2005
02: "Make Mine Steel". Acrylic on wood, 2006
03: "Northern Exposure". Acrylic on wood, 2007
04: "Dancing Bears". Acrylic on masonite, 2009
05: "Riding with Rudy". Acrylic on board, 2004
06: "Red Rider". Acrylic on wood, 2009
07: "High Societweed". Acrylic/fabric on wood, 2010

63

3 KO MASUDA.

Kosuke Masuda (KO) is an artist and Buddhist monk of Shingon sect, living in Yokohama, Japan. KO's interest in surfaces and carving into his chosen material eventually led him to begin experimenting with using a router on perspex and aluminium, which in turn led to his engraving on bicycle parts creating sought-after custom pieces of art with a practical application.

Working equally, as always, from the subconscious and the creative process itself, KO's compositions began to lose obvious representation and move freely into abstraction. Rather than the graphic picture within the pictures' compositions of the wood-carvings, these new intricate engravings on bicycle components began to flow freely and loosely, influenced by the tools and the medium itself. The compositions began to loosen and suggest images, such as figures and landscapes, often without directly representing them.

As KO develops new techniques and experiments with new ways of producing his art, we will be able to watch his progression as an artist, and the way his life as a person and Buddhist monk influences it.

MB, Yokohama, Japan, 2006

3 LINDA APPLE

"My mother once told me that I started to draw as soon as I could hold a pencil. I have no memory of that, but I do remember that, during those early years, art was all I thought about."

Growing up in the Appalachian hills of Southern Ohio, delighting in drawing and painting at an early age, Apple received artistic support from creative and loving parents. She was awarded a scholarship to the "Columbus College of Art & Design" in 1964 and that was the first step of a life-loving journey into the creation of art. Always seeking new ideas and experiences, Apple was led to France, Italy, Greece, Sweden, Mexico, Canada, and the Southwest of the U.S.A. Over the past 43 years her work has gained international recognition being exhibited in Mexico, Canada, and the U.S.A. while finding its way into many prominent collections around the world. Personal experiences and other life changes have influenced and altered her work many times throughout her career of 40 plus years. Through the earlier years, along with painting, she created large sculptures in wood, stone and welded metal and today she continues to produce smaller mixed-media sculptures.

The technical and personal aspects of her work have merged to produce touching and whimsical images that stir the imagination and inspire the viewer to notice the little everyday moments of our life.

01: "Great Day". Oil on canvas, 2011
02: "Aqua Angle". Oil on canvas, 2010
03: "Group Hug". Oil on canvas, 2010
04: "Where Did They Go?". Oil on canvas, 2011

3 LOU READE.

New York became Lou Reade's ground for establishing her series of bicycle paintings and other bicycle related mixed-media pieces. During a visit, Lou developed an awareness of the abandoned bicycles throughout the city. They became questionable and intriguing objects.

The newly inspired work, which took shape as she returned to her home in England, combined a range of styles and ideas, including postcard-sized images and various styles of print, and not casting aside Lou's traditional form of painting.

Following her inspiration, she made a visit to Amsterdam, a city of bicycles, which only furthered the eager ambition to extend her bicycle series.

Lou is interested in the linear form of the bicycle. It is purely a form to play with on the canvas, becoming more expressive and colourful as the series progresses. Lou's personal interests do not reflect highly in the bicycle series: "The question I am asked most about my art is: '*Do you ride bicycles?*' My answer is: '*Not really*'."

Lou likes to think of her bicycle series as a lighthearted preoccupation, in which a fixed subject allows her to toy with her style of working.

The series has allowed Lou to participate with her work in many bicycle themed exhibitions, which have so far shown her bicycle paintings in both the United Kingdom and the U.S.A.

Lou's other paintings are also inspired by the places she visits, including New York, San Francisco, Amsterdam and Venice.

01: "Yellow Bicycle in Amsterdam Study".
Mixed media on paper, 2009
02: "White Bicycle".
Acrylic on canvas, 2010
03: "Bicycles in Amsterdam Study".
Acrylic and carbon print on paper, 2010

01: "Bike in Burnham".
Acrylic on canvas, 2009
02: "Yellow Bicycle in Amsterdam".
Acrylic on canvas, 2009
03: "Four Bikes in Amsterdam".
Acrylic on canvas, 2009

3 "LUMA BESPOKE"

Peter Lin, co-founder and creative director of "Luma Bespoke" joined forces with Louis Lui of "Luma" in 2010 and launched their first "Luma Bespoke, Steel Art Collection" at the "Bespoke Creative Show" in Brick Lane, London. The collection attracted support from many renowned people such as Lord Brian Roberts Davidson and Jimmy Choo Obe.

This collection of fixed gear bike frames is an extension of personal style and a fashion statement. They are adorned with graphics by twelve of the world's leading and up-and-coming creative designers in the industry including Vault 49, Peter Lin, Adhemas Batista, Ollie Munden, John McFaul, Ben Thomas, Jasper Wong, Ben Qwek, Aaron De La Cruz, Ria Dastidar, Danielle Hunt, and Yvonne Tang. Each steel art frame has its own style and character that can reflect its owner's unique personal identity.

"Luma Bespoke" believes that cycling is an art form, more than a mode of transport. Therefore, people should not be hesitated to use their bike frames as canvases to express themselves!

01: "Dreamy Wonderland 2", 2011
02: "Dreamy Wonderland", 2011
03: "Dreamy Wonderland 4", 2011
04: "Oriental Fantasy 3", 2011
05: "Oriental Fantasy", 2010

3 MR KERN

"My childhood was hard enough: I was raised by wolves in a wood near Bordeaux. Painting was pretty complicated for me: we had no 'paint by numbers' so I learned to paint 'by bite'. In effect, the only tools at my disposal were a brush made with the armpit hair of a wild boar, natural pigments, and the egg white of wild canaries to mix it all ... but you do what you can ..."

MR KERN
paintings about

01: "Pichoukern". Painted with acrylics, 2009
02: "Kernacho Thinking to a Big Biking Girl". Painted with acrylics, 2011
03: "Le Point de Vue de Pinpin Sur la Byciclette". Painted with acrylics, 2011

MRKERN.COM

3 "MWM".

MATT W. MOORE – "MWM GRAPHICS"

Matt W. Moore is the founder of "MWM Graphics", a design and illustration studio based in Portland, Maine. Matt works across disciplines, from colourful digital illustrations in his signature "Vectorfunk" style, to freeform watercolour paintings, and massive aerosol murals. Matt exhibits his artwork in galleries all around the world, and collaborates with clients in all sectors. Matt is also co-founder and designer for "Glyph Cue Clothing."

01: "Momentum". Mural. Boston / USA, 2009
02 & 03: "Momentum". Hand-painted bike.
Photo © Keena, 2009
04 & 05: "Momentum". Vectorfunk poster series, 2009
06: "Momentum". Hand-painted bike. Photo © Keena, 2009

3 PETER J. KUDLATA.

art House studio

Peter Kudlata lives and works in his home studio in Wisconsin, U.S.A. Peter is an abstract painter working on canvas with acrylics. One facet of his art involves his passion for bicycling; from racing to commuting, from tricycles to recumbents. Bicycling is a universal proposition. From childhood to adulthood, one of life's best realizations of freedom is when that parent's guiding hand lets go.

01: "Chrome Bike". Wall art sculpture, 2010
02: "East Side Bike Criterium". Triptych acrylic on canvas
03: "Bike Starting Line". Acrylic on canvas

79

3 SHERRI DAHL.

"My paintings are a representation of what my perception of 'human' is. This is my life experience with people and their objects, put down with colour and form. Domesticated objects represent the average human in my culture. The abundance of man-made materials in this society shows how humans have shaped our world. There is not enough natural earth anymore; people have made their own super-natural world. Humans think of themselves as the dominant species as they take everything possible and manipulate it for their own use. The more we try to manipulate and control the world, the more 'human' we make it.

I think of myself as a realist. I want my paintings to give a real vision and essence of what it is like to live here and now. The complexities and repetitiveness in my paintings are reminiscent of the chaos in city life. My work should not show the traditional landscape or the idyllic human life as we have seen in art history. Instead, my work shows how we live in a post-production society. Images of several human-related objects give the viewer little glimpses of the different trends and stylistic changes we see in our culture. I want my work to show how objects like toys, electronics, cars, bicycles, hats, and eyewear are symbolically 'human' hence 'domesticated' and how they have styles that come, go, coincide and stay.

My paintings are chaotic and filled in with layers of form and colour. Intersecting and overlapping objects overwhelmingly cover the bulk of the compositions in my work, mimicking our urbanity. I always paint in front of my subject, from observation versus from photos, so I can have a heightened mind and body experience while working and put more perception into my work."

01: "Accumulated Bike Parts". Oil on sheet metal (steel), 2008
02: "Bike Frames". Oil on sheet metal, 2009
03: "Rollfast". Oil on canvas, 2007
04: "Accumulated Bicycle Scrap". Oil on canvas, 2008
05: "Locks and Keys". Oil on canvas, 2009

3 STEVE DENNIS.

Steve Dennis learned to ride a bike in the mountains of Wales, then to race on the velodrome in London and the criteriums in New York. Now he rides in headwinds in Chicago where he lives with his wife and daughter. "Nothing beats the sensations and freedom experienced whilst riding man's most beautiful machine. I paint cycling portraits to share those feelings and ignite those memories in the viewer. We don't remember every detail we saw as the peloton passed so I strive to capture these instances, preserving the spirit, emotion and essence of cycling."

01: "Kessler". Acrylic on canvas, 2007.
Photo © David Ettinger
02: "Keith at Goodwood". Acrylic on canvas, 2004
03: "FixyLife". Ink on paper, 2011
04: "Breaking Away 4". Ink on paper, 2010
05: "Breaking Away 3". Ink on paper, 2010
06: "Kuurne". Ink & acrylic on paper, 2010.
Photo © David Ettinger

83

3 TALIAH LEMPERT.

Photo portrait © Amy Bolger
01-03: "A Long Row of Bike Silhouettes".
Mural on a barrier that separates a bike lane
from the street on Flushing Ave., Brooklyn, NY / USA
04: "Evelyn's Bike". Oil on paper, 2010
05: "Ryan's Freedom Deluxe". Oil on canvas, 2011

"Bicycles are important, beautiful and worth a close look."

Taliah Lempert moved to New York in 1989 to study painting at the "NY Academy of Art". She started cycling for transportation and found a culture. In a few years, Taliah has done for bikes what Wayne Thiebaud did for desert – painting the subject in order to have us reconsider the beauty in the everyday. Taliah has been painting bicycles of all speeds and sizes for over a decade. Her compositions have been displayed in numerous shows and in various publications.

"Most bikes I paint are, or have been, used daily for transportation, recreation, messenger work and/or for racing. They are worn and customized uniquely, being at once a specific bike and a collective symbol of empowerment."

3 TIAGO DEJERK.

Tiago DeJerk, born in Brazil and resides in North America, is an all-around bicycle artist. He doesn't own a car and has been riding bikes since he was a little child, so it comes to no surprise that bicycles would not only influence his art, but become a major theme. When he performs as a clown, the tall bike becomes an extension of the artist. As a painter, the eye-popping, multi-layered stencils reflect not only the machine, but the culture it creates. As a sculptor, he builds freak bikes out of disposed and abandoned old bicycles.

He is a proud member of the world famous "Dead Baby Bike Club", through which he's always proud to showcase his creations.

Photo portrait: "Bike Portland".
Photo © Jonathan Maus
01: "Dogeye". Spray paint on recycled wood
02: "Cyclepath 02". Spray paint on recycled wood
03: "Pedalpalooza". Spray paint on recycled wood

01: "Horny Bars". Spray paint on recycled wood
02: "Captain Insano". Spray paint on recycled wood
03: "Single Speed". Spray paint on recycled wood

3 PAINTINGS PUZZLE.

01 & 03: Artist: Mark Skulls
02: "The Commodification of Subculture Part 1". Artist: Insa. Spray paint on perspex, 2011
04: "Brie". Artist: William Lazos
05: "Bicicleta". Artist: David de La Mano

SE ACABÓ DE IMPRIMIR
ESTE LIBRO EL 30
DE JUNIO DE MIL
NOVECIENTOS TREINTA
Y OCHO EN LOS TALLE-
RES GRÁFICOS DE LA
CALLE PERÚ 666,
BUENOS AIRES.

ion positivo

01: "Untitled". Artist: 2501. Made for the
"Painkiller" exhibition at "Tag and Juice Gallery".
Sao Paulo / Brazil, 2010
02: Artist: Other
03: "Guache Scene". Artist: Cern
04: "Adrenaline". Artist: Aryz

01: "When the Wheels Fall Off …". Artist: Stormie Mills
02: "Fluor Bike". Artist: Okuda
03: Artist: Stohead
04: Artist: Mr Wany. Event "Ciclo Arte". Live performance at "Brain Storming Gallery". Milano / Italy, 2010
05: "The Three". Artist: Drypnz
06: "Dodocycle". Artist: Michael Cheval
07: "Hank". Artist: Alison Elizabeth Taylor. Marquetry, Shellac, 2007
08: "Painting … The Little Man". Artist: Klaas Lageweb
09: "Bicycle". Artist: Jessica Brilli. Oil on canvas, 2005

4 ILLUSTRATIONS-DRAWINGS.

On the following pages we present you bicycle art work drawn from illustrations and drawings.

Artist: Andy Singer, page 100

4 ADAM TURMAN.

Adam Turman is an illustrator and screenprinter from Minneapolis, U.S.A. He loves four things very much: burgers, beers, babes and bikes; and his work reflects those things on a regular basis. Adam has a passion for all things: BICYCLES. Personally he owns more bikes than fingers and toes and currently has all of those. More often than not you can find him on his bike delivering bike-related art work, commuting and riding with his family all over the "Twin Cities".
Get out and ride your bike in the meantime.

01: "Penny Farthing"
02: "Choose the Bike Red"
03: "Cycle Minneapolis"
04: "Vive le Tour King of the Mountain"
05: "Ride Gravel"
06: "Peace"

4 ADAMS CARVALHO.

Adams Carvalho lives and works in Sao Paulo, Brazil. He is working with illustration, painting, and animation. His illustrations are inspired by photographs of cyclists. He began to develop illustrations of bicycles to encourage bicycle use for transportation in your city.

4 ALAIN DELORME.

Born in Versailles, in 1979.

"In 2009, I got the opportunity to do an art residency in Shanghai. I bought a bike right away, to live the city as an inhabitant rather than a tourist. The idea of my "Totems" series came up a few days after: I got a feeling of vertigo due to the constant effervescence of the city and its permanent stimulation of all senses. All of a sudden it made so much sense: I should create a series about accumulation. I also had the feeling of a China oscillating between the dazzling modernity of its towers and the simplicity of a part of its population in the street, a feeling I wanted to reflect in my pictures.

The impressive loads of the migrants appear to me as the perfect illustration of both phenomena. Most of the migrants were bicycling like me, so I started following them throughout the city and shooting them with their bizarre burdens. I called them "Totems" for their verticality, which echoes the height of the skyscrapers in my photos.

Expropriating the codes of photo reportage, I used photomontage to exaggerate the loads and to offer a reshaped view of China's new urbanism in the run up to the "2010 Universal Exhibition". The streets of Shanghai bristle with these moving "Totems", precarious assemblages of ordinary objects, symbols of the "made in China".

This willful departure from reality leads us to observe the 'real' more critically and question contemporary China and beyond, our own consumer society."

01: "Totem # 15". Photo © Alain Delorme.
By courtesy "Magda Danysz Gallery", 2010
02: "Totem # 5". Photo © Alain Delorme.
By courtesy "Magda Danysz Gallery", 2010
03: "Totem # 9". Photo © Alain Delorme.
By courtesy "Magda Danysz Gallery", 2010
04: "Totem # 4". Photo © Alain Delorme.
By courtesy "Magda Danysz Gallery", 2010

4 ANDY SINGER.

Andy Singer is a two-headed, six-armed alien from the planet "Neptor". His multiple heads and arms enable him to be a very prolific artist. He was sent to earth over 40 years ago to observe humanity and make small drawings of what he sees. In addition to drawing cartoons and illustrations he has become co-chair of the "Saint Paul Bicycle Coalition" in Saint Paul, Minnesota. He can be seen bicycling around town on a special blue bicycle, designed to accommodate his eight legs. If you see him, say "Hello" and don't be intimidated. He's really friendly.

01: "Bike to Work 2". Pen and ink with computer colour, 2008
02: "Bike Power". Pen and ink with computer colour, 2010
03: "Lady Liberty Leaves the Car (for Transit and a Bicycle)". Pen and ink, 2008
04: "Bike Race". Pen and ink with computer colour, 2000
05: "Low Gear". Pen and ink with computer colour, 2003
06: "Cycling Through the Ages". Pen and ink, 2001

4 BLANCA GOMEZ.

"People like bikes because bikes like people. They seldom throw us to the rough asphalt. They usually take us from point A to point B without taking our money, like other means of transport do, neither protesting against the world like cars and motorbikes do ..."

01: "Cyclist". Digital illustration, 2009
02: "La Beauté est Dans le Rue". Poster, Digital illustration, 2011
03: "Blanca". Sketch on paper, 2011
04: "Biernes". Poster, Digital illustration, 2010
05: "Freewheeling". Poster, Digital illustration, 2010

LA BEAUTÉ EST DANS LA RUE

POR FIN ES
BIERNES

4 CHRIS KOELLE.

"Inspired by antique photographs of people posing with their bicycles, the original "Sweet Ride" drawings sparked in me an ongoing fascination with the history of cycling, travel and roads, from the "Good Roads Movement" of Horatio Earle to the epic, sprawling interstate highways we love and hate today."

01: "Bring It"
02: "Weather Pain". From Bike Snob (Chronicle Books, 2010)
03: "He's Not Kidding v2.0"
04: "The Messenger". From Bike Snob (Chronicle Books, 2010)
05: "Double Dog Dare You"
All images © 2011 Chris Koelle

OUT OF MY WAY

THE MESSENGER

DOUBLE DOG DARE YOU

4 CHRIS PIASCIK.

"I am an artist and a graphic designer residing in Connecticut. I post daily drawings on my blog, Monday through Friday. I also have an apparel company called "Print Brigade". I was trained in the black art of sleep deprivation by small men from outer space.

I've been bike-crazy my entire life. This series documents in great detail every bike I have ever owned. I drew each bicycle and then surrounded them with hand-lettered descriptions and memories. There are 32 bicycles in the series."

Photo portrait: "All My Bikes"
01: "Flings"
02: "MKE"
03: "FBM"
04: "WTP"
05: "Panasonic"

Commute SNAP-PED TURBO FRONT BRAKE CONVERSION
STEEL
HERE Panasonic 700c 6 BIG
ROAD RAMP
FIXED gear 44x16 FAST

4 CHRIS WATSON.

"I've always loved to draw pictures and ride bikes fast. On holidays, as a kid, I saw stages of the "Giro d'Italia" and the "Tour de France". Every Sunday morning I'd head out of town with my dad and our club, the "Central Scotland Wheelers", for hilly back roads like the "Duke's Pass", "Tak Me Doon", "Crow Road" and "Yetts O'Muckhart", often in wind, rain and snow. After we'd been riding all day, I could eat like a horse! I was a skinny kid, so I could climb quickly and loved to speed downhill. I had a winter hack and a shiny red bike for sunny days and races. At art school, I dropped cycling for girls, beer, rock'n'roll and motor-bikes. Fast forward to when my wife was expecting our first baby boy, I realized that I wanted to be strong for my new family, so I started to ride weekly with the local club, doing the odd road race, hill climb and time trial winter training on fixed gear. Lately, I've been drawing for some great cycling magazines and have so many ideas for new bike art projects – watch this space!"

01: "Alcohol". "Cycling Active" magazine
02: "Time". "Cycling Weekly", sketchbook page
03: "Racer"
04: "Recession"

01 "Winter Blues". "Cycling Active" magazine
02: "Spring". "Cycling Health & Fitness" magazine
03: "Summer". "Cycling Health & Fitness" magazine
04: "Autumn". "Cycling Health & Fitness" magazine
05: "Winter". "Cycling Health & Fitness" magazine

"COG"

"It was in May of 2007 when the idea for "Cog" was hatched in "Breakaway Bicycle" courier's office. Eric, myself, Kevin, and others gathered on the greasy couches and threw ideas into the mix. Pretty quickly we realized we knew people spanning the globe who are living with bicycles as we were. We reached out to them and they were excited by our idea about this magazine. Weeks went by and we made calls, so many calls to friends and companies and companies of friends and some of them liked our idea enough to even support it through advertising! We spent the summer compiling content and still making those calls. By September we had built our first issue and were ready to roll with it. If nobody liked it – worst case scenario – we had a great summer art project that went nowhere. The people not only liked it, but loved it! Over three years later we've managed to publish ten issues, one hardcover book and hosted three photo exhibitions. We've made many new friends and grown closer to our old ones through what has become a global communal effort. We couldn't be more humbled by the amazing work our contributors have provided for us ... out of goodwill and the love for two wheels."

Peter DiAntoni

01: Artist: Matt Lingo. Photo illustration
02: Artist: Taliah Lempert. Monoprint
03: Artist: Kevin Sparrow. Stencil painting
04: Artist: Will Manville. Monoprint with detail

COG

COG — 08 — FEBRUARY, 2010

4 "CRICKET PRESS".
BRIAN TURNER

Brian Turner is one half of the husband and wife design studio, "Cricket Press". Based in Lexington, Kentucky, "Cricket Press" has been illustrating, designing and hand-printing gig-posters and various art and ephemera since 2003. Brian is an avid cyclist and advocate of bikes, as well as a prominent member of the bike scene in his hometown. The expressive quality of the bicycle in all its varied forms has long been an inspiration in Brian's art work.

01: "Overgrown". 5-colour screen print, 2010
02: "Battle Ready". 4-colour screen print, 2009
03: "Scorcher". 4-colour screen print, 2009
04: "Stingray". 3-colour screen print, 2009
05: "City to Shore". 3-colour screen print, 2008
06: "Hide and Seek". 4-colour screen print, 2011

4 DAMARA KAMINECKI.

Death's Chariot

Damara Kaminecki, a.k.a. "Damarak the Destroyer", dwells in a tiny apartment where she sleeps atop her flat files and carves linoleum deep into the night. Originally hailing from Chicago, she can now be seen riding through Brooklyn, carrying stories of wonder and groceries on her back.

4 DAVID PINTOR.

David Pintor. Born in Coruna, Spain, 1975. Awarded by the "Society of News Design (SND)". Selected for "Bologna Book Fair" in 2007, 2010, and 2011. Selected for "Bratislava Biennale" in 2009 and 2011. "Grand Prix Clermont Ferrand Carnet of Voyage Biennale".

01: "Bikerman"
02: "Worldbike"
03: "Cafe Belén, Madrid"

4 EMILIO SANTOYO.

Emilio Santoyo lives and works in California as a freelance illustrator. His work combines a studied, technical hand with an innocent eye and heart, giving him a rare and unique voice that stands apart. He is inspired by cartoons, junk in backyards, modes of transportation, movies that have been watched multiple times, and the joys and events of life. Each project becomes a research project in a way that both the viewer and Emilio love. When it comes to his work, clean, bold graphic, fun, and exciting become his aesthetic.

When he isn't in search of a great burrito, he is working on a new project: A comic, an illustration, a product for his online shop, a shirt design and even some sketches for new sculptures.

Photo portrait © Diana Kwok
01: "Chubby's Spoke Card". Digital, 2010
02: "Tall Bike Koozie". Emilio spocket product, 2009
03: "All Together Now". Gouache on paper, 2010
04: "With You I See Clearly". Gouache on paper, 2010
05: "Tiger Bike". Gouache on paper, 2010
06: "Bike Parade". Gouache on paper, 2007

121

4 "FIRST FLOOR UNDER".

FIRST FLOOR UNDER — "First Floor Under" comes to life at an underground location in Milan, "Via Leto Pomponio 3/5". It's a digital publishing company dealing with vanguard pop productions through the most popular medium of the 21st century: the network. It has two souls: it not only produces content to be periodically uploaded on its web page but it also organizes real events within the "Tbwa" Milan exhibition area.

01-06: "Scatto"

4 FRANCIS KMIECIK.

Francis Kmiecik is an artist from Los Angeles by way of Chicago. He graduated from "The School of the Art Institute of Chicago". There, he studied scientific and fashion illustration, animation, and film. His recent bike illustrations were inspired by the growing Chicago bike community and the beautiful girls that ride them. The bicycle was the perfect object to challenge his technical interests. Drawing fashionable women has always been a subject that interested him, so it made perfect sense to combine both.

01: "Kelly"
02: "Alley"

01: "Smoke and Water"
02: "Smoke and Water". Vadims Tattoo

4 HUGH D'ANDRADE.

Hugh D'Andrade is an artist and a troublemaker. He has been involved with "Critical Mass" in San Francisco since it began in 1992, and he has produced art work and graphics for "Critical Mass", the "San Francisco Bicycle Coalition" and dozens of other events and causes.

CRITICAL MASS

VISIONARY TRAFFIC JAMS SINCE 1992

01: "Critical Mass" flyer. Pen and ink, 1993
02: "Critical Mass 10th Anniversary". Poster, offset litho, 2002
03: "Critical Mass" flyer. Pen and ink, 2002
04: "SF Bicycle Coalition Winterfest". Offset litho, 2007
05: "SF Bicycle Coalition Winterfest". Offset litho, 2010

4 IAN HOFFMAN.

"My name is Ian Hoffman. Some of my favourite things are pedals, pixels, pencils, and prints – not necessarily in that order. I currently live in Vancouver, British Columbia, and I only have four bikes. I am a graphic designer at "Sugoi Performance Apparel" and an illustrator doing work for "Mountain Equipment" co-operation, "Momentum" magazine, "Obsession" bikes and many more. I hope my work is familiar – at first – and then – on another level – it tells a story in lines and colour. When it comes to work on the bike frames and some of my other occupations, there is also a sense of exploration as you get into the maze of lines and shapes that make up the characters – there is always a need for characters in my drawings and always a need to tell a good story."

01: "Commuter"
02: "Mountain Equipment" co-operation
03: "Family on Bikes"
04: "Bike Crash"
05: "Chopper"
06: "Bent"

4 ILOVEDUST.

"Ilovedust is a multi-disciplinary design boutique. We specialize in creative solutions from graphic design and illustration to animation and trend prediction.

We ply our trade in two contrasting studio spaces; one located in the heart of East London and the other on the tip of the South Coast. Just a short stroll from the ocean and surrounded by the rolling Hampshire countryside, our South Coast team enjoys a distinct vantage point working in a former butcher's workshop. Conversely rooted in the heart of creative hub Shoreditch, our London studio thrives on the buzz and energy of the city in a converted tool-maker's foundry. The blend of both environments provides us with a unique and inspiring perspective.

We mix some of the best British designers along with talent from around the globe. We collaborate both in-house and with global brands, working together to create fresh, innovative design which makes up our award-winning portfolio."

01: "Clarence St Cyclery Mural"
02: "Bad Image Chain Links"
03-05: Tokyo fixed gear, custom bike

4 JAMES GULLIVER HANCOCK.

James Gulliver Hancock is an illustrator and visual artist. Originally from Australia, he is now based in Brooklyn and he is attempting to draw all the buildings in New York. He has worked for clients such as Coca-Cola, MTV, Sony Music, The New York Times and Herman Miller among many others. He feels ill when he isn't making something, riding his bike or flying kites.

01: "Bicycle Valentines". 2-colour silkscreen on paper, 2009
02: "All the Bicycles in Berlin". 1-colour silkscreen on paper, 2011
03: "Take a Ride". 2-colour silkscreen on paper, 2010
04: "Bike". Pen and ink on paper, 2008

4 JANET BIKE GIRL

"I love bicycles. I love stencils. My art combines these two things. I have a bicycle art studio in downtown Toronto. I want to see bicycle art everywhere, on the streets, in your home, at your job. Bicycles are beautiful and I try to show that through my art work."

01: Alex and Janet Bike Girl. Photo © Glenna Lang
02: "Critical Mass New York City"
03: "Bicycle Nuit Blanche". Janet Bike Girl's "Open Studio"
04: Bicycle stencil collage
05: "Dream Bicycle"
06: "Bike Bike"

135

4 JAY RYAN.

Jay Ryan lives and works very close to Chicago. He has been biking since 1976 and making screen-printed rock concert posters since 1995. Jay's company is called "The Bird Machine" and he plays bass guitar in the rock band "Dianogah".

01: "Screens 'n Spokes", 2008
02: "Cargo Flip"
03: "Screens 'n Spokes", 2009
04: "Screens 'n Spokes", 2007
05: "The Recyclery"

4 JENNIFER DAVIS

"In 2010, "Bicycling" magazine crowned my city, Minneapolis, Minnesota, the number one bike city in the U.S.A. While I am not among the (insane?) crowds of winter bikers (we also received over 80" of snow last year), I live for spring when I can hop on my bike to get anywhere I want, to go via zillions of miles of paved bike paths. It is one of the best things about living in Minnesota. In addition to riding bicycles, I like to draw and paint them.
The model for my painting, "Curious" was my own bicycle. However, the alien is a work of fiction. Any resemblance to me is purely coincidental."

Photo portrait: "Keep On".
Acrylic, charcoal and graphite on panel, 2008
01: "Navigator". Acrylic, collage and graphite on panel, 2007
02: "Tricycle". Acrylic, collage, charcoal and graphite on panel, 2009
03: "Curious". Acrylic, charcoal and graphite on panel, 2010
04: "Remember". Acrylic, charcoal and graphite on paper, 2009
05: "Bike Ride". Acrylic, charcoal and graphite on panel, 2010

4 JESSICA FINDLEY.

"These bicycle aura portraits are part of a larger series I made of people who I love and who love bikes. Some of these people are famous to the world because of their relationship with bikes and some are famous to me and give me inspiration.

I started drawing auras as an attempt to exorzise my ex's bad qualities and enhance the good gifts. I enjoyed making auras so much that I used the same technique to made these portraits especially for the "Bicycle Film Festival" art show "Joy Ride". After that, I was hooked and I made an "Aura Booth" installation. It was like a photo booth with me inside instead of a camera. You were putting your money in the slot and I was peeking through a prism and drawing your aura. All the raised funds went to a local non-profit organization "Green Apple Kids", which provides creative and educational environmental after school programs for kids.

I can't actually see auras. I just feel them."

01: "Lucas Brunelle". Watercolour, 2010, ⓘ
02: "Francesca Tallone". Watercolour, 2010, ⓘ
03: "Maki Hojo". Watercolour, 2010, ⓘ
04: "Sadek Bazaraa". Watercolour, 2010, ⓘ
05: "Jessica Findley". Watercolour, 2010, ⓘ

4 KEN AVIDOR

"My fascination with the weird nexus of transportation, politics, religion, and crime has distracted me from working full time on comics for several years. The good news is that all that dark, creepy stuff I've researched is going to be ploughed into my comics – stay tuned."

While many artists dabble in newsprint-magazine illustration work, few can include courtroom sketch artist on their resume. Ken Avidor can. Over the years, Avidor's illustrations have frequently showed up in publications including "City Pages" and the "Pulse". He has also contributed with his work to the local comic publication "Lutefisk Sushi" as well as "Cifiscape Vol. I", "The Twin Cities", a collection of illustrated sci-fi stories set in the future.

Jessica Armbruster (citypages.com)

Photo portrait: "Tall Bike Knight"
01: "Dirtrag Knights"
02: "Flying Knights"
03: "Carhenge"
04: "Crossbow Cover"
05: "Overpass"
06: "Bike Polo Roller Derby"

BIKE POLO & ROLLER DERBY IN HELL
By Avidor

4 KRISTA TIMBERLAKE.

"I grew up in Western Massachusetts and now I live near San Diego, California. Though I work full-time as a graphic designer, I need to find time to ride my bike, practice yoga and create fine art to feel at all balanced. As an avid cyclist of almost 25 years, a fitness addict and a former premed student, I have a great appreciation for the body as a complex machine. As a lifelong art consumer and producer, I naturally find the human form beautiful and everlastingly inspirational. I am particularly fascinated at how the body and bicycle meld to become a single, better and more efficient machine than either could be individually. Artistically, I have always found well-crafted machinery very alluring and the modern bicycle is a wonder of functionality, craftsmanship and design. I hope those who see my art, whether they are cyclists or not, will see a bit of mechanism brought to the figures and a bit of softness and organic, fluid energy instilled in the bike imagery."

01: "Highroller". Lithograph
02: "Shadow Ride". Lithograph
03: "Dynamism". Pastel on illustration boa

4 MADS BERG

"I'm living, loving and working in the capital of Denmark, Copenhagen, with my wife and three kids. Working as an illustrator and a visual artist, I simplify my characters and objects in the artwork as much as possible up to a minimalistic level, where motive and aesthetics have equal presence. My great interest is particular in ancient and modern art and the inspiration I collect from that is really what fuels my fire and makes me want to express my work through illustrations."

01: "Velocity"
02: "A38 Bicycle Girls". Detail
03: "A38 Bicycle Girls"
04: "Copenhagen"
05: "Bornholm 10"

4 MIKE GIANT.

"I started riding bicycles when I was seven years old. My first bike had a banana seat with a "Mako" shark on it. Then my dad bought me a "Mongoose" BMX at the flea market for like $ 30. For years after I would buy bikes at the flea market, fix them up and ride them for a year or so until they'd get stolen. I must have gone through six or seven bikes that way. I quitted cycling when I picked up skateboarding in 1984.

In 1997, I got a free bike from a friend in San Francisco and started riding daily again. I got my first fixed gear bike in 1999 in trade for a tattoo. The following year, I picked up a real track bike, a '80s "Gitane", in another tattoo trade with the same guy. Since then I've had lots of bikes of all sorts.

Currently, all my bikes were built custom just for me. I've got a full carbon road bike from "Cannondale", a street cruiser from Jordan Hufnagel in Portland, a basket bike from "4130" here in San Francisco, my "Macaframa" track bike from "Raleigh" and a gold bike I got from "PH Bikes" in Australia."

01: "San Francisco Cyclist: Becca"
02: "San Francisco Cyclist: Katy"
03: "San Francisco Cyclist: Karina"
04: "The Modern San Franciscan"
05: "Tribute to Ed Roth"
06: "Track Fire". Self-portrait

~THE MODERN SAN FRANCISCAN~

- WEARS A CERTIFIED CYCLING HELMET, JUST IN CASE
- HAS BEEN TO EUROPE FOUR TIMES
- AN INTELLIGENT MIND
- VINTAGE GLASSES
- GOES TO YOGA CLASS THREE TIMES A WEEK
- HOOCHIE-MAMA HOOPS
- LETTING HER HAIR GO
- VINTAGE WOOL SWEATER
- EATS A VEGGIE BURRITO AT PANCHO VILLA AT LEAST ONCE A WEEK
- A KIND HEART
- HEMP SCOOPNECK
- LIKES BOYS WITH BIG HANDS
- TATTOOS BY GEORGE CAMPISE, CHRIS CONN, MIKE DAVIS, GRIME, ED HARDY, JASON KUNDELL, TIM LEHI, HENRY LEWIS, MARCUS PACHECO, JUAN PUENTE, JEFF RASSIER, SCOTT SYLVIA, JEF WHITEHEAD
- SMOKES HELLA WEED
- PERFECTLY CURVED HIPS
- HANDMADE COTTON CYCLING PANTS
- REAL BOOBS
- NO PANTIES
- LIVES IN THE MISSION
- POWERFUL THIGHS
- IRON GRIP
- MEDITATES DAILY
- WORKS RETAIL ON UPPER HAIGHT
- NON-LEATHER CYCLING GLOVES
- RIDES A VITTORIA RANDONNEUR IN BACK FOR LONG-LASTING FLAT PROTECTION
- CUSTOM FRAME MADE BY AN EX-BOYFRIEND
- FOUND ALUMINUM BARS
- ATE LOTS OF LSD IN HIGH SCHOOL
- HATES TELEVISION
- SHAPELY POWERFUL CALVES
- HAS NEVER OWNED A CAR
- DOESN'T HAVE HEALTH INSURANCE
- HAS A GIRLFRIEND ON THE SIDE
- BLADED CARBON FIBER FORKS FOR STYLE POINTS
- BENDIX COASTER BRAKE HUB - JUST PUSH BACK
- PREFERS PBR
- PHIL WOOD HUB BECAUSE SHE LIKES TO GO FAST
- "PART-TIME MODEL"
- BLACK VEGAN CYCLING SHOES
- STILL USES A FLIP PHONE
- RIDES A VITTORIA RUBINO PRO UP FRONT FOR SUPERB CONTROL
- RUNS EVERY RED LIGHT
- VELOCITY DEEP V RIMS FOR STRENGTH AND STIFFNESS
- FUCKS ON THE FIRST DATE
- LOVES GUMMI BEARS

01: "Young Love"
02: "Rollin 49ers"
03: "Life and Death Machines"
04: "Vitti Fire"
05: "Solimo"
06: "Frisco Rider"

YOUNG LOVE
- IN -
"THE PARIS OF THE WEST"

DEATH MACHINES

LIFE MACHINES

4 MONA CARON.

Mona Caron is a Swiss-Italian artist, illustrator and muralist living in San Francisco where she became a regular bicyclist during the 1990s. Her outstanding contributions to the burgeoning San Francisco bike culture (and ultimately the world's) came first in the form of a 6 m x 104 m mural along the city's first dedicated bikeway, depicting a semi-surreal vision of the common San Francisco bicycling route from east to west known as the "Wiggle". Later, she made the iconic poster for the 10th anniversary celebration for "Critical Mass" in 2002, enshrining a mythical young woman as one of the world's best known images of the new cycling culture.

Chris Carlsson, writer, "Critical Mass" co-founder, author of "Critical Mass, Bicycling's Defiant Celebration"

01: "Bicycle Revolution", 2011
02: "Bamboo Bikes", 2003
03: "Vélorution", 2002
04: "Turn Left!", 2008
05: "Critical Mass, 10th Anniversary", 2002

4 MONSIEUR QUI

Parisian street artist and illustrator, Monsieur Qui likes dogs, cats, brass bands, and especially riding the streets of Paris with his bike to find good spots for painting or paste big wet paste on dilapidated walls.

01: "Ride with Elegance on Authority"
02: "Bike on Plate"
03: "Ride with Elegance"
04: "Untitled"
05: "Born to Die"

4 NATE WILLIAMS.

Nate Williams, a successful artist, illustrator and designer, has worked extensively in varous facets of the illustration industry with a wide variety of clients. Originally from the Western U.S.A. Nate calls America his home and his graphic illustrations come alive in a vivid, exciting world of his own creation. Layers of organic shapes, ethnic references, intricate decorative elements, hand-drawn type and unique characters combine to create rich, engaging imagery. In addition to his illustration and fine art work, Nate conceived, designed, launched and maintains the highly successful illustration community portal illustrationmundo.com. He is currently working on licensing his art work for a variety of products worldwide.

01: "Beautiful Life"
02: "See You Around"
03: "Life is Beautiful"
04: "RE: Vision"
05: "Red Bicyclette"
06: "Date Book"

4 PAT PERRY.

Pat Perry is an artist and illustrator born in the Detroit area and now calls Grand Rapids home. The lands of the North, colourful people, music and the ordinary streets of the Midwest have always inspired him. Whether drawing or painting, Perry creates some kind of art work every day. In between showing his art from coast to coast or working with an assortment of clients, Pat tries to travel as much as possible. Although Pat is happy to be able to speak and have an audience through his artwork, he does his best everyday to listen and learn from the world he lives in.

01: "You Blew It Colour"
02: "Untitled"
03: "Bike Brains"
04: "Flower Face"

4 REMEDIOS.

Her love for nature and the sweetness in her gaze are explained by her origins; she was born in Bogota in 1987, from the union of a veterinarian and poet, passionate for tango and horses and an environmental tourism promoter, lover of both pre-Columbian culture and first queen of Panela (Brown Sugar) in Colombia.

An illustrator since she has a memory, Maria Camila, "Remedios", started to create her imaginary worlds in her Math and Spanish notebooks at a nuns school, in Villeta, a warm region surrounded by green leafy trees, rivers, and skies adorned by birds. She studied design and graphic arts and now creates prints for the "Converse" female line for Centre and South America, from the City of Panama.

A smiley and an explorer, armed with a sketchbook and hundreds of colour pens in her bag, she intervenes on walls, streets, bodies, helmets, surfboards and on almost every surface that falls in her hands with the only purpose of creating. With monocycles, old bicycles, fishes, birds, yellow butterflies, ornaments, and other beasts. "Remedios para el amor" ("Remedies for love"), "Remedios para volar" ("Remedies for flying"), "Remedios para la lluvia" ("Remedies for the rain") ... A thousand remedies she dreams to convert into clothes and accessories through latiendaderemedios.com, a commercial and artistic project on development.

01: "Remedios para Papá"
02: "Remedios para Juan"
03: "Remedios para Constanza"
04: "Remedios para Volar"

4 RICCARDO GUASCO aka RIK.

"I am an Italian painter and illustrator. I research the lightness of shapes and the chromatic heat and I do it with few colours and a simple line. I love the red, black, white, and gold, Picasso, Charlie Chaplin, and carefree bicycles."

01: "Costante Girardengo"
02: "Italo"
03: "Fausto"
04: "Albert"
05: "Diaul"
06: "Sante Pollastro"
07: "City on Bike"
08: "Coppi"

COPPI

4RUSL.

"I like aesthetics but I can't make things that are only superficial. Beauty to me is elegance in function, everyday. I wish we could be surrounded by tools as beautiful as the natural world – tools that inspire our work, play, and loving. I believe in the fertility of co-creating, copying, and sharing, these features constitute a creative process. So, don't hide your ideas! I've been a bicycle activist and advocate of car-free cities since 1997. My wife Jane and I live in Vancouver, British Columbia, with our two boys, Finnegann and Francis. I'm currently making bicycle family cargo bikes for local use."

Photo portrait © David Grove, 2003
01: "Free Spirit Drive End".
Oil monoprint diptych on rag paper, 2003
02: "Free Spirit Front End".
Oil monoprint diptych on rag paper, 2003
03: "We Ride by Night".
Centre panel from intaglio triptych on rag paper, 2002
04: "Strong FAT!SO Women". Mixed media, 2004

165

4 "SHORTYFATZ".
SAMUEL RODRIGUEZ

Samuel Rodriguez currently lives in San Jose, California, where he works as a graphic designer and illustrator. Some of his most recent works are permanent public art installations for the "Los Angeles Metro Authority" and the City of San Jose. He also runs a graphic design house called "Shortyfatz".

Samuel first became serious about art through graffiti at the age of 11. During this time and years after, his favourite aspect of graffiti was tagging because of the instantaneous expression one can carry out from it. Since then, he has expanded on this interest through the discovery of various visual topics and mediums including bicycles.

Samuel views bicycles as a great form of alternative transportation that is very accessible and unique to each individual. He believes they can be as ordinary as a mailbox, or as interesting as an art sculpture on wheels. For him, they are a great way to visually frame everyday slices of life.

01 & 02: "Urban Dualities". Art Series 4 out of total 20
03: "Starring Shortyfatz"
04: "Urban Dualities". Art Series 4 out of total 20
05: "Custom Bike Factory"

shortyfatz

CUSTOM BICYCLE FACTORY | 408.588.0000 | SHORTYFATZ.COM | 725 N.10th ST. SAN JOSE, CA 95112

S H O R T Y F A T Z

4 "THE RIDE".

"Born, as all good things are, out of a conversation over Mexican food and beers, "The Ride" is an all encompassing focus on two-wheeled obsession. We know that most people who share our enthusiasm with bikes don't want to be pigeonholed as roadies, freeriders, track racers, BMXers, XC riders or even commuters. They are just riders. We wanted to create something for them.

The idea was to create a collection of personal stories. Bikes have changed people's lives in so many ways and we wanted to gather a small selection of these tales. We didn't want to give reviews or race reports, we wanted to get under the skin and expose the passion that flows through riders' veins.

Once the seed was sown, we spread the word to people from all across the globe. Initially we wondered if it was just us who wanted to see such a journal; evidently we were wrong. From all kinds of riders we began to get favourable responses. People asking why this hasn't been done before and how they could join us.

Besides the incredible writing we also wanted the magazine to be equally strong visually. Artists, illustrators, photographers have given "The Ride" the strong, simple visual style it has become respected for.

01-04: Artist: Lovedust. Illustration, "The Ride" Journal covers

The Ride

4 WILL MANVILLE.

"I ride real fast baby, I don't ride slow".

Born in 1988, originally from the San Fernando Valley in Los Angeles, California, Will Manville is a graduate of the "California College of the Arts" in San Francisco. His main focus is monotypes, screen-prints and spray can art. "Speed, fluidity, movement, shape, place, gesture, emotion. My goal is to capture the beauty of line and pure movement of simple shapes, expressed through intuitive gesture. My mark-making records the changeable emotions I experience at the moment of creation. The fluid nature of my work is a result, expressing those feelings through rapid calligraphic gestures, bringing the images to life. Currently my fascination with the simple shapes of the bicycle allows me to best express that natural gesture."

Photo portrait © Christina Monzer
01: In collaboration with artist Bob Motown, "Two Rabbits Studios"
02-04: "Untitled"
05: "'80s Bike Gym"

4 ILLUSTRATIONS-DRAWINGS PUZZLE.

01: Artist: Ciro Schu
02: "Vietnam on Two Wheels". Artist: Tim Doyle
03: "RHC-Brooklyn 3". Artist: Jonah Birns
04: "King of the Road". Artist: Jeremy Slagle
05: "Fixed". Artist: Aske, Sicksystems
06: "pRide". Artist: Leandro Castelao

pRidE

01: "Traffic Monday". Artist: Huebucket
02: "Kamen, Ghost and Booth".
Artist: Dennis Brown
03: "Cycletracks". Artist: Matt Oxborrow
04: "Spokes and Leaves".
Artist: Mia Nilson. 2010, ⓘ

01: "Fixie Freak 300". Artist: Lahe
02: "Cycles of Life". Artist: Gera Luz
03: Artist: Josué Menjivar & Fresh Brewed Illustration
04: Artist: Sergio Gomez Caballero a.k.a. "Srger"
05: "Bike by Land, Boat by Sea".
Artist: Evan B. Harris. Acrylic on paper
06: "Stacked". Artist: H.Veng.Smith a.k.a. Veng. Watercolour on paper
07: "Fixies Jam 1". Artist: Sean Kane

01: "Monster Bike". Artist: Aleksei Bitskoff
02: "Breaking LA Logo". Artist: Flying Förtress
03: "Pelitour en Villa Alemana". Artist: Alexander Pompeya
04: "Bikeride". Artist: Neuzz
05: "Angermuller002". Artist: Lifter Baron. Poster for "ArtCrank" show. San Francisco / USA, 2010
06: "Singlespeed". "Fixie Retro Race Bike Art Print". Artist: Dirk Petzold
07: "All I Need". Artist: Same84

Singlespeed
Classic Race Performance

www.dp-illustrations.com

5 TATTOOS.

On the following pages we present you bicycle art work by tattooers with themes mostly taken from bike parts like gears, chains etc.

Artist: Micael Tattoo

5 TATTOO PUZZLE.

01: Artist: Miguel Angelo
02 & 04: Artist: Will Manville
03: Artist: Brass Monkey, ①
05: Artist: ABT Tattoo
06: Design by Erosie. Artist: Lil'd, East Atlanta / USA. Tattoo owner: Matt Pensworth
07: "Ride 2 Live". Artist: Sake. Tattoo owner: Vaggelis Dimosthenous, 2011

01 & 02: Design: Kurt Rampton.
Artist: Matt Greenhalgh
03: "Biker Forever".
Artist: Ciscoksl, 2010
04-06: Artist: Jeremy Swan / Broken Tattoo
07: Artist: Tee Jay / White Tiger Tattoo

08: Artist: Olivia / Sacred Art Tattoo. Tattoo owner: Vicky Richardson. Photo © Jacky
09 & 10: Artist: George Long. Tattoo owner: Kori Quatermass
11: Artist: Andy Barrett / TattooAndy
12: Artist: Donnie Kizzee / Metamorphosis, Indianapolis / USA. Tattoo owner: Jaime Mariel W.
13: Designer and tattoo owner: Michael Cleveland. Tattoo artist: Mark Lee / Tat2FX, München / Germany

6 SCULPTURES.

On the following pages we present you bicycle art work by sculptors using different mediums. In this category, we also include bicycle sculptures made with recycled bike materials, crochet acrylic yarn etc.

ALASDAIR NICOL.

Alasdair Nicol is a creator and a producer working in both worlds of art and design. He has worked extensively in public art, festivals, and theatre, driving a diversity of collaborative and community-focussed projects including knit graffiti installations, flamboyant dressings of historical statues and live sculpture performances.

As an artist, Alasdair works both individually and as a member of "Reef Knot" – a dynamic, Sydney-based artist collective. His artworks focus on the re-purposing and celebration of disused and pre-loved objects. Alasdair's public art and installation works are driven by a desire to engage non-traditional art audiences. He has taken part in countless solo and group exhibitions, installations, festivals, and theatrical productions across Australia.

01 & 02: "The Bike Bike". Artist: Alasdair Nicol.
Work in progress
03: "The Bike Bike". Artist: Alasdair Nicol.
Commissioned by the City of Sydney as part of "Art & About", Sydney / Australia, 2010.
Photo © Matthew Venables

WILF LUNN.

Wilf Lunn first came to public notice in 1942 when he won the first prize in a "War Baby" competition, which he believes was because he was shaped like a bomb. Raised by deaf parents in a cellar in Yorkshire, England, Wilf, as a baby, learned quickly that farting was better than crying for attracting their attention.

James Mason, the film star, whose parents lived on the same street as Wilf, recognized Wilf's talents and introduced him to an agent. This led to an exhibition of Wilf's cycles. On the opening night, Joan Bakewell, the TV presenter, asked Wilf if he'd like to be on television and so he did his first TV show, "Late Night Line Up".

This was the start of Wilf's long TV career in the UK, which included: "Late Night Line Up", "Magpie", "Vision On", "Eureka", "Jigsaw", "Ask Aspel", "Patently Obvious", "Object in Question", "Jim'll Fix It", "What's the Idea", "Game For a Laugh", "6 o'clock Show", "Home James (James Mason documentary)", "Mad Science", "The Word", "See It Saw It", "3,2,1 (game designer)", "Mooncat", "Magic Music Man (Art Director)", "Fun Factory", "Rolf on Saturday", "Fantastic Facts (with Jonathan Ross)".

01: "Marquee Press"
02: "Undesirable Person Pursuit Cycle"
03: "Ladies Vice Cycle"
04: "Worm Catcher Cycle"

6 CARO.

Carolina Fontoura Alzaga a.k.a. Caro is a multidisciplinary artist with a penchant for repurposing castoff materials and exploring socio-political themes.

Hailing from Mexico, Brazil, and the U.S.A. Caro's work is informed by her lifelong movement between spaces and cultures. What she produces are reflections and documents of these environments and her artistic vocabulary evolves with these shifting realities. In 2007, she received a B.A. with an emphasis on painting and digital art from the "Metropolitan State College" of Denver. Caro is based in Los Angeles, California. The "Connect" series consists of multiple light sculptures in the form of traditional chandeliers yet made of recycled bicycle parts. This developing body of work draws inspiration from traditional to modern chandeliers, DIY, punk, and bike culture and follows an art tradition of utilizing non artistic materials for sculpture.

01: Work in progress
02: "Connect 17", 2010
03: "Connect 27", 2011
All images © Alan J. Crossley

MATT CARTWRIGHT

"I am a designer and a fabricator and I have worked within many different communities. I design and build functional art, sculpture, and custom furniture or fixtures to meet a client's needs through collaboration, innovative design, and creative use of new or recycled materials. Often, I will use a recycled material because I am inspired by its normal use. I am most prolific with metal, but I also use just about any new, used or surplus material that I may encounter. I like to see how things can be rearranged or combined to develop new parameters for thought.
Through creative projects and other private commissions I am able to practice and keep developing a sense of proportion and detail. I enjoy any project that allows me to work in a scale and place with which people can interact.
I am open to collaborations, private commissions, and specific fabrications."

Photo portrait: "Sunset Bike Girl". Photo © Evan Liebermann
01: Recycled cycle cyclone fence for "River City Bicycle" store, Portland / USA
02: Aluminum rim garden chairs
03: An adjustable solar panel support and a prayer wheel designed and fabricated for the "Matthew Sheckel Lifehouse Memorial"

6 DAVID GERSTEIN.

Gerstein's sculptural protagonists are all in motion – walking, running, riding bicycles, driving cars, playing ball, skiing, dancing. Never at rest, seldom introspective, they are always outwardly orientated, giving rise to a hectic, yet un-threatening mode of being. Gerstein wishes to trace the basic elements of form and the way these change as positive and negative, in depth, and in perspective, as they transform in the interplay of two- and three-dimensional spaces, of light and colour and the influence of motion on these ingredients as a whole. "I am not interested in sports in particular, as a personal fascination or a thematic engagement. What I try to study and what fascinates me are pure visual aesthetic motives, as when seeing a group of runners or bicycle riders. I am immediately drawn to elements of volume and space created inside a group of people engaged in a sports activity. I try to trace and re-enact the visual illusions which change constantly, even in a scientific mode." By using hand-made brushes and repetitive vertical hand-gestures, Gerstein captures the physical sensation of the eye in its mode of perceiving the world, the light and the motion around us and he does it in an impressionistic style, repeating the same scene again and again, in a manner which brings to mind Seurat's fascination with the circus and Monet's studies of the "Rouen Cathedral". Yet, instead of oil paint on stretched canvas, he uses epoxy car-paints on hard and cold steel, usually in several layers.

Gerstein, the sculptor-painter, invites the viewer to a stroll in the magical world of colour, of form, and of movement through his individual, virtuosic, figurative syntax and his allusions to the history of Modern Art. In his constant, outward repetition of motives, as well as in his serial productions of sculptural artefacts, he relinquishes the uniqueness of the work of art for the sake of spreading it out like seeds in the air, following the spirit of Dada, Pop, and even of Conceptualism. He invites the viewers to endorse the colours and the movement of the lines – to observe and enjoy the visual experience once more.

by *Irena Gordon*

01: "Infinity Rally". Wall sculpture, hand-painted cutout steel, 3 layers. Limited edition, 2010. Photo © Ran Erde
02: "Infinity Tour". Wall sculpture, hand-painted cutout steel, 3 layers. 2 parts, limited edition, 2010. Photo © Ran Erde
03: "Tour de France". Wall sculpture, hand-painted cutout steel, 3 layers. Limited edition, 2002. Photo © Ran Erde
04: "Peloton Wave". Wall sculpture, hand-painted cutout steel, 3 layers. 2 parts, limited edition, 2008. Photo © Ran Erde
05: "Armstrong". Free standing bronze sculpture. Limited edition, 2008. Photo © Ran Erde

6 DEREK KINZETT.

Derek's work has been described as beyond beautiful, stunning, and spiritual. In 2004 he launched "The Inner Spirit Collection" of hand-crafted, life-size wire sculptures, which has continued to grow in size and content. Derek's work has gained recognition and respect for its intricacy and detail, receiving commissions from clients such as Tim Green of the "Tate Gallery", Lord Ethan Stewart and the actor Nicolas Cage. "The Lady & the Bicycle" was released in 2010 for exhibition to "Orleans House Art Gallery", Twickenham, London.

01-03: "The Lady & the Bicycle"

6 JOE GAGNEPAIN.

Joe Gagnepain is engaged in the task of creating something meaningful from society's refuse, working it into monumental works of art. Gagnepain mimics living forms with inorganic matter, creating animals, insects, plants, and whimsical abstractions from garbage. He works primarily in metal and plastic; including bicycle parts, plastic toys, antique metal pieces, car parts and anything that can be scavenged to reduce environmental impact.

Joe believes that his art should serve the interests of his community by offering accessibility of his work for all to enjoy and be inspired by. Gagnepain's pieces are meant to be outside, to be viewed by many, and to be close to the natural world which informs them. To Joe, inspiration comes from many places and interaction with the public is an important part of his artistic process.

Gagnepain began using bicycles in his monumental sculpture assemblages in 2000, when he and a team of friends created "Recycled Dali Horse" for a city art project titled "Pedal Geneva", the year after the "Cows on Parade" event in Chicago that triggered public art movements around the country. Since the "Dali Horse", Joseph has taken an enjoyment using bicycle parts as a sculpture medium, to produce such monumental works as "FoxCycle", "MooseArt (a 12" tall moose)", "Windcycles (windmill)", "Mantis!", "CommuniTree", "Liontopia", "Gil the Fish", a "CycleFlake" snowflake and "Whimsy Whorlie Wheelie Interactive Kinetic Bicycle Contraption" for "Naperville Children's Museum". With the mechanical abilities inherently built into bicycles, every piece Joseph builds has some degree of moving parts, powered either by the wind, human interaction, or motors.

01: "Recycled Dali Horse". Artists: Francis Joseph Gagnepain IV, Peter Weitl, Clifford Lo, Tim Stopka & Rebecca Kunstman. Geneva / USA, 2000
02: "FoxCycle". Artists: Francis Joseph Gagnepain IV & Gordon LeBlanc. St. Charles / USA, 2001
03: "MooseArt". Artist: Francis Joseph Gagnepain IV. St. Charles / USA, 2002

Dzine

Sifting through the rituals of faith, folklore, urban memorial, youth, and custom culture, Dzine has created unique sculptures that contextualize these diverse elements into a vernacular of contemporary aesthetics. His bicycle sculptures can be seen as an offering poised on an altar while being a precisely fabricated work of contemporary sculpture appearing pensive and thoughtful revealing a universal aspect of competition and showmanship, while also hinting at solitude and isolation. The final results are a hybrid of personal monument, memorial and obelisk.

Dzine is represented by "Leeahn Gallery", "Daegu, Salon 94", New York and "Scai the Bathhouse Gallery", Tokyo.

This series addresses class codes, power dynamics, reclaimed agency and ecological responsibility. These subversive objects challenge the aesthetics and symbol of wealth by juxtaposing the classic elegance of the chandelier with the newfound elegance of discarded, mechanical bicycle parts. The names of some of these parts, i.e. link, lynchpin, hub, spokes, carry an elevated significance in this détourned context. "Connect" is a metaphor of potentiality in collectivity. It imagines what is possible with each unique chandelier form.

01 & 02: "Barrio Dreams". Custom lowrider bicycle. 24 kt gold plating, custom engraving chrome, enamel, Swarovski crystals, rubber and mirror, 2007. Photo © Andreas Larson
03: "Return of the Crown Prince". A carriage for Haile Selassie. Metal, oak and cherry wood, 23 kt gold leaf, vintage boom-boxes and speakers, car audio, electronics, mirror, velvet, rubber, and Swarovski crystals, 2009.
Photo © Andreas Larson
04: "Untitled". Custom lowrider bicycle. 23 kt gold and pure silver leaf, Swarovski crystals, chrome, custom engraving, enamel, car paint, velvet, steel, rubber, bondo and mirror.
Photo © Andreas Larson
05: "Untitled". Custom lowrider bicycle. 24 kt gold plating, enamel, bondo, steel, rubber, custom engraving, Swarovski crystals and mirror. Photo © Andreas Larson
06: "Samlor". Custom cycle rickshaw, enamel, rubber, car paint, fibreglass, plexiglass, gold and chrome plated engraved metal, suede fabric, Swarovski crystals, 23 kt gold leaf, artificial flowers, vintage chandelier, custom lowrider tires, audio (realized and assisted with generous funding provided by Paul and Linda Gotskind), 2010.
Photo © Pablo Mason

01 & 03: "Throne to the Last Emperor of the Forbidden City". Custom lowrider bicycle. 24 kt gold plating, custom engraving, enamel, bondo, steel, rubber and mirror. Photo © Andreas Larson
02: "Sweet and Sour". Enamel, car paint, fibreglass, plexiglass, gold and chrome plated engraved metal, suede fabric, Swarovski crystals, 23 kt gold leaf, vintage and custom jewellery, rubber, audio, 2011. Photo © James Prinz
04-06: "La Casa de Mi Abuela". Detail. Ghost bike memorial. Enamel, pearlized car paint, metal, mirror, fabric, audio, video, Swarovski crystals, gold plating, silver, custom jewellery, rubber. Photo © James Prinz

MARK GRIEVE & ILANA SPECTOR

Fine art is more crucial than ever for the survival and health of our species. A vibrant art culture is an indication of a vibrant society. "J.F.K.", while honouring poet Robert Frost, on October 26th, 1963, said, "The nation which disdains the mission of art invites the fate of Robert Frost's hired man, the fate of having 'nothing to look backward to with pride and nothing to look forward to with hope'."
Local artist Mark Grieve, born in 1965, started drawing in 1966 (primarily abstract for the first few years), until his formal education at the "San Francisco Art Institute" and the "College of Marin", where, under a series of excellent instructors, he learned painting, drawing and ceramics. His exhibition history is varied, starting with gallery settings in the 1990s, evolving to large-scale combustible temporary art, to most recently, creating public sculpture.
Ilana Spector, born in 1974, graduated "cum laude" with an international economics degree from "Georgetown University's School of Foreign Service", with a stint at the "London School of Economics". She also graduated from "U.C.L.A.'s School of Law". After practicing law, she became CEO of one of Southern California's first solar electric companies. She has lived and worked in India, sold art, and consulted in various capacities. She is currently Mark Grieve's partner, welder and collaborator.

01: "Suspended Wheel Composition". Discarded bicycle wheel rims. San Francisco / USA, 2008
02: "Hanging Wall Composition".
San Francisco / USA, 2008
03 "Cyclisk". Landfill-bound bicycles. Commissioned by the City of Santa Rosa / USA, 2010
04: "Cyclisk". Landfill-bound bicycles. Commissioned by the City of Santa Rosa / USA, 2010. Photo © David Haines
05: "Double Archway". Discarded bicycle wheel rims. Temporary site-specific fine artwork for "Jazz and Blues Festival". Commission by the City of Glendale / USA, 2009

201

OLEK.

"A loop after a loop. Hour after hour, my madness becomes crochet. Life and art are inseparable. The movies I watch while crocheting influence my work and my work dictates the films I select. I crochet everything that enters my space. Sometimes it's a text message, a medical report, and found objects. There is the unravelling, the ephemeral part of my work that never lets me forget about the limited life of the art object and art concept. What do I intend to reveal? You have to pull the end of the yarn and unravel the story behind the crochet.

My work changes from place to place. I studied the science of culture. With a miner's work ethic, I long to delve deeper and deeper into my investigations. My art was a development that took me away from industrial, close-minded Silesia, Poland. It was always sought to bring colour and life, energy, and surprise to the living space. My goal is to produce new work and share it with the public. I intend to take advantage of living in New York with various neighbourhoods and, with my actions, create a feedback to the economic and social reality in our community."

All images: Crocheted 100% acrylic yarn on a bike, ⓘ

283

7 TYPES.

On the following pages we present you some special types of bicycles:
Bicycles designed "on the desk" waiting a call for production. Special bicycles regarding their design and look, already "on the streets". Kinetic bicycles made for festivals and exhibitions and many many more.

Artist: Thomas Neeser, page 229

7 "AZOR".
KONSTANTIN DATZ

"The idea of the "Azor" bicycle is to invent a space-saving and foldable bike. Unfortunately it's just a concept for now. I think it's very convenient to have a bicycle that you can unfold when you need it.

My name is Konstantin Datz, I am studying industrial design at the "University of Applied Sciences, Potsdam". I am 22 years old and I live in Potsdam, Germany."

"BIKE 2.0".
INODA SVEJE

Inoda Sveje is a design studio located in Milan, Italy, working mostly in the fields of furniture design, medical devices, and renewable energy.

"Bike 2.0", the winner of "Seoul Cycle Design Competition 2010", is a contemporary remake of the best ever personal transportation, the bicycle is made in collaboration with "Ipu" product development in Denmark. It offers uncomplicated great technology at your fingertips (toe-tips). Whether you use it as a substitute for a normal bike, without battery, but with the chainless transmission and small power boosts from recollected break-energy, or as a substitute for a far more polluting vehicle, with the power assisted pedalling from the battery, it will bring you around in a subtle yet cool manner. The design is meant to be contemporary in aesthetics and ethics, a symbiosis of form and technology, modern and historical. "Bike 2.0" will use standard wheels and forks, because it just makes sense, but this also gives you the possibility to personalize your "Bike 2.0". The user interface consists of two turning rings, one for gearing and one for energy supply.

BME DESIGN
"ONEYBIKE" & "FAJNYJE2" PETER VARGA

Peter Varga was born in Slovakia in 1981. He works as an industrial and graphic designer, freelancer, and designer in "+421 Design Studio". He currently lives in Bratislava.

"Oneybike", 2010. "14th International Bicycle Design Competition 2010", Taiwan, merit prize. "Oneybike" is a leisure bicycle concept inspired by the classical high wheeler simplicity, connected with the comfort of a recumbent bike. All together designed in modern lines and features, with a little bit of retro feeling. Folding mechanism is made really simple and effective, which makes this bike easy to use and ride.

"Fajnyje2", 2007. Folding city bicycle, graduate thesis. Bike simply folds in just 2-3 seconds. Bike still stands on its wheels, and there is no problem with handling. Easy to use, drive and store.

7 BRANO MERES

Although Brano's professional history is aimed mainly in the field of thermal power engineering and district heating networks, for many years he has been dealing with design of bicycles and bicycle components. Brano has a strong passion for bicycles and he likes to create bicycle frames using unconventional construction methods and various materials, such as bamboo, carbon fibre, titanium, wood, natural fibres etc. His bicycles are not only an art work, but can be ridden as well.

01 & 04: Carbon fiber C-Thru frame
02: First bamboo MTB frame
03: Titanium rivetted frame

7 "CARBONWOOD".
GARY GALEGO

Australian furniture maker Gary Galego works from his atelier located in Sydney's central suburb of Newtown. He possesses a rare attitude in today's fast-paced, virally-linked and throw-away world where at the heart of his slowly evolving practice lays an uncompromising approach to quality and longevity. He explains that every piece is made to reflect the highest level of refinement and strongly believes that well-designed and well-made products are not disposed of but collected, cherished, passed on and recycled into new times and new environments. Employing modern manufacturing in combination with traditional hand techniques, he creates pieces that are simple and elegant in appearance but somehow transcend perceived limitations and conventionalities within the traditional craft of cabinetmaking.

In an age where there is growing emphasis on individuals becoming more environmentally responsible and promoting greener technology, the bicycle can fuse important cultural ingredients within modern cities. An important consideration when designing the "Carbonwood" bicycle was to utilize a material which had a sustainable and green resource. By using wood, the design takes a very basic material and celebrates the artisan nature of fine making whilst maintaining a form conducive to cutting edge wood manufacturing technologies.

The plywood laminations, which make up the structure of the bicycle, are essentially a composite material, comprised of wood and carbon fibre. From plantation of grown and sustainable harvested trees, the veneers are rotary cut which means the veneer is peeled from the log and there is absolutely no waste.

7 "ECO // 07".

The "Eco//07" is designed by Victor Alemán/Estudio, a Mexican team which is always concerned with the innovation, sustainable processes, and trendy designs. The "Eco//07" is a compact urban bicycle, a green transport that does not consume energy. It's proposed to be made of bioplastics obtained from algae and stainless steel parts.

"Eco//07" has an innovative wheel folding system that is designed to maximize the functionality of the bike with clever mechanisms that compact the object in order to transport it and store it in small places. Once the product is packed, it only uses a space of a little box, allowing the user to take the bike to any trip.

All parts that compose the bike are standardized, replaceable and easy to fix by the user, which maximizes the useful life of the product.

7 "GREEN SHADOW".
JOSÉ MARÍA PARRA

"My name is José María Parra. I am an industrial, graphic, and interior designer. I have worked in the field of design all my life in different kinds of projects. In this moment of my life I work on my own brand called "Mister Onüff" based in Madrid, Spain. I love my work. The passion is the driving force in my work, and I try to express this emotion and force in each of the projects all times.

"Green Shadow" was a concept bike for a video game project. The project should have an 'ecological look' expressed by the colour and bold design."

7 "HIDEMAX".
SERVET YUKSEL

The concept project of the "Hidemax" bicycle by Istanbul based product designer Servet Yuksel uses bent steel plates for its frame instead of the standard hallow tubes. This design choice gives this bike a very unique appearance with many features that couldn't have been realized on a tubular frame. For one, the frame appears to be a single continuous piece of metal with the exception of the curved rear suspension that is inline with the frame. The front handle bars are adjustable and the seat sits on the frame rather than being on a post. Yuksel carries the flat metal design over to the wheels with a minimal eight spoke design. All these features make up an unusual bike that plays with the preconceived notions of two-wheeled design.

7 "HMK 561".
RALF KITTMANN

"Hmk 561" is an ultralight motorbike with a new drive concept, which is located between the wheels. The one-piece carbon frame was especially developed for braiding machines which allow for a fast, efficient and cost-effective production. Suspension and bearing are integrated in the frame during the braiding process. Weight reduction is only one of various advantages which carbon implicates. The carbon fibres' electrical conductivity enables the powering of board devices, such as tachometer and lighting, by using the frame structure itself. A layer of carbon fibres is used for self-monitoring. A particular web of conducting fibres registers damages to the frame and provides a permanent structure monitoring for the biker.

The frame also serves as an accumulator. The carbon fibres' special layer structure makes it possible that the energy for driving can be stored directly in the frame. The principle is similar to that of a condenser. The special design is due to the drive concept. Front and rear swingarm are designed modularly. Two electric motors are integrated in each of them. They transmit the power counter-rotarily directly to the rims. During speed reduction, the energy is regained. In car parks and while waiting in front of traffic lights, the accumulator are charged inductively. The usage of the latest drive technologies, of fibre composite and lightweight concepts mirrors the design and thus follows the current trend of a new environmental awareness.

7 "IBIKE"
REINDY ALLENDRA

"I am an industrial designer from Indonesia and I also consider myself as a concept artist. Me = Design + Music + Movies + Sketching + Cars + Future, every single thing around you could be an inspiration. Automobiles are usually the vehicles where you can see high tech body designs emerging. But not this time. This bike was a concept model designed by me for a lifestyle and bike design competition. Because music is a big part of my lifestyle, it brought me the idea of a concept bike that would combine a music player with a standard bike.

The wheel movement powers the music player which has a convenient docking station on the handle bars and an ear plug port is conveniently located below that. The wheel movement also can power a tail and break light. It's a smart bike, eye-catching, with a futuristic bike design."

1 "KTM X-STREET"
CHARLES-EDOUARD BERCHE

"The street is a playground for grown-up children. All kind of bicycle riders and motorbike riders have the same target. Having fun performing tricks in unusual places. A bike is agile but the rider is limited to his own physical power. On the other hand, a motorbike is powerful but the rider is disadvantaged by the dimensions of his/her motorbike.

The "X-Street" is an innovative concept bike with an electric assistance that enhances your ride. Human energy is directly transformed in electric power. One part is used. The other part is stocked for a more efficient mode. All technical parts are compacted in the main body to improve agility. The frame is a mix between a tubular frame and a carbon frame. All is designed to improve lightness. The carbon allows having free shapes to replace body panel. The fork is inverted for integrate a front lens and a video camera for shooting your ride session and share it with your friends. Most of the time, we do not need a saddle for this type of use. Therefore, it is deleted for having a compact bike with a strong identity."

7 "LOCUST".
JOSEF CADEK

"To my customers recruited from transportation, consumer goods, electric tools, construction machines, and medical industry I offer complex design services: design concept work, product development, design implementation, design communication, advanced 3D modelling, photo realistic rendering, visualizations, freehand sketching, hand-modelling, design feasibility studies, engineering. I love the world of design because it is about creating something with your brain, hands, mind and soul. This human touch elevates your work to a creation rather than just a product. And that is the most beautiful thing about design. In my work, I seek new ways to solve problems and issues, ways that have never been tried and maybe never even been considered. For example, the bicycle is an invention over 100 years old. During that time, many bicycles have been designed and many engineering and design solutions applied, and over the years, time and experience have decided which of them are vital and which of them we now see only in museums. It may seem hardly possible to come up with something new, fresh, and innovative. But this is exactly what is so exciting about creating new concepts and things for the future. When I design a product, I always look for the 'inner meaning' of things. I can say of my work that the outward appearance of my designs is always the conclusion, never the starting point. 'form follows function' is a fundamental truth for me. Better still, 'form follows meaning'."

7 "NULLA".
BRADFORD WAUGH

To this day, the "Nulla" bike is the only bicycle that Bradford has designed, which is surprising in the light of the response it's garnered. The "Nulla" concept was actually the product of a transportation design class in school where, being so fed up with his peers' endless renditions of sports and cars, he decided to design a bicycle instead. Bradford is the owner and director of a small studio based in Philadelphia, Pennsylvania, where he takes on a variety of clients.

7 "OKES".
REINIER KORSTANJE

The way of transporting yourself is becoming a bigger issue in modern society. The choice of your vehicle reflects your image and special lifestyle. This solid oak bike is a response to our society of mass production, and goes back to the time of quality, of durable, hand-crafted, "one of a kind" products.

This "Okes" bike frame is made out of solid French oak wood with superb quality. Using a different material than metal pipes used in classical bike frames, resulted in a bigger variety of shapes to design the pure and stylish shape of the bike.

The frame is "CNC-milled" in a little town in Belgium at Hout Ambacht, a factory making high quality, custom, solid oak interior products for the last six generations. The frame was made out of four solid parts glued together. The constructive characteristics of oak wood made it possible to use the material on its own without constructing materials inside. Sandblasting the frame gave it its beautiful wood structure back. Mat oil made the wood better resistant to sunlight and rain.

The bike was finished off with extraordinary but classic looking metal accessories. No plastic parts or unnecessary breakable parts where added. This "Okes" bike is a simple but stylish, pure, and durable lifestyle bike you want to be seen on.

"ORYX"
HARALD CRAMER

"Oryx" is an innovative time trial bike with one-sided fork and chain-stay. Due to its Y-frame it is comfortably shock-proofed without loosing ground contact. Each bike is custom-made which guarantees the perfect, individual ergonomics for every driver and simplifies manufacturing: handle bars, stem, and fork are made of one piece and therefore are aerodynamic, lightweighted, and durable. The ergonomically shaped seat post and saddle are integrated in the frame and possess a special hole, reducing heat. Leather cover and gel flow finish the saddle.

Frame and handle bar are connected via a frame-pivot, guiding cables through the frame as well. One of the innovations on this bike is the crank which is designed like a ring and mounted in the inside of the frame by two ball bearings pressed into the frame. The cranks reduce damages by the chain and improve aerodynamic. They are connected directly to the chain ring without any shift lever. A special construction made of carbon composite, which is baked into the frame during the manufacturing process, helps guiding the chain and cables through the frame. It is more durable than normal carbon fibre and therefore protects the frame and the chain stay.

"Oryx" is controlled by a hub shift lever with an integrated drum brake, which means the shift lever is in the inside of the hub. The hub is part of the three-spoke-carbon fibre wheels, which can be removed in only one second. In time trial races, like the "Contre la Montre" at the "Tour de France", every second counts, that's why "Oryx" possesses an identically pair of wheels, designed to be removed by only one button without knowing which wheel is affected in case of emergency.

The upper shift lever is located in the handle bars at the end of the triathlon handle bar. For ergonomical reasons they are mounted revolvably. As the bike possesses only one shift lever, the handle bar lever can be mounted individually left- or right-handed. Each part of the bike which gets in direct contact with the driver is gel flow protected, allowing great comfort by lowest weight.

Harald Cramer's "Oryx" design won him a $1,000 scholarship from the "2007 Dimension 3D Printing Group Extreme Redesign Contest".

01: First concept drawing with radically new crank and integrated chain
02: Fully integrated parts lead to an aerodynamic appearance
03: The hub-speed is integrated in the wheel, which can easily be changed by one push-button
04: Handle bars, stem and fork are a carbon monocoque with integrated gel pads

7 RAFAEL GEORG SCHMIDT.

Born in 1976 in Tichau, Rafael Schmidt studied architecture at the "University of Applied Sciences" in Frankfurt and achieved a master's degree in architecture at the "ETH" Zurich, department of "Computer Aided Architectural Design" under the chair of Prof. Ludger Hovestadt. Since 2001, he has been working with different international architects such as Zaha Hadid Architects and Foster & Partners. In 2007, he founded "Rafaa", an award winning studio for architecture and design based in Zurich. The studio critically analyses the contemporary architectural discourse and combines the insights gained with creative inventions, new technologies and design by research. The collaboration with different artists such as photographers, composers or curators is a further key element. The art installation "J'adore Aglisia" was shown at the "06. Berliner Kunstsalon" and the "Swiss Art Award". Rafael Schmidt was a guest critic at the "University of Kassel" and the "Architectural Association School of Architecture", known as "AA School", in London. He is currently teaching at the professorship for "Architecture and Urban Design" under the chair of Prof. Marc Angelil at the "ETH" Zurich.

7 "SANDWICHBIKE" & "DOWNTOWNBIKE".
BLEIJH

"We at Bleijh like the product 'Bicycle'. Especially in these days, where we have all kinds of knowledge of the situation regarding mother nature. Aspects that are affecting our lives on a daily basis. Things like greenhouse effect, pollution, poverty, drainage of natural resources, and so on.

We feel that the bike is such an honest product, that it is always worth improving. It makes people travel the globe on a very friendly manner. It is a product that has a long lifespan, when it is put together out of quality components. And not only that, it also provides work for people as it needs service along its lifespan."

"Sandwichbike". The "Sandwichbike" is the result of Basten Leijh's and Pieter Janssen's work. They both have been looking at the bike market for some time and came to the conclusion that there are a lot of chances for improvement. Improvement, for example, in the field of production, assembly, and sales.

Bicycles look the way they do because not a lot of people have read between the lines. And that is exactly what Basten and Pieter did. Why is a bike being produced and pre-assembled before it reaches the customer? Why is almost every bike being sold in a shop, which makes the bike more expensive? These are questions that Basten and Pieter tried to answer differently.

The intentions of solving these problems led to the "Sandwichbike". Using the concept of flat packing and home assembly that has been made popular by companies like Ikea, Basten and Pieter made a bike for the customers to assemble in their own backyard, with only one simple tool.

Following function the bike is made out of two wooden plates. The two plates hold together four identical "smart cylinders" that house all the technical parts needed, like the crank axle, the head tube and the seat post. The absence of welding joints makes the frame easy to produce and the materials used could be varied according to the clients' demand. This way, the bike can be kept simple and cheap as well as aesthetically and structurally supreme and therefore reasonably expensive.

"Downtownbike". The "Downtownbike" is the project that Basten Leijh used to graduate from the Design Academy in Eindhoven in 2002. The goal was to fill up all the gaps left open by the current market and create the ideal city-bike by combining consumer's needs, current available technical solutions, and some clever engineering.

Market research showed that there are some essential specifications where there is room for improvement. Theft, damage, storage, safety, and cargo. To solve these problems, Basten turned only to solutions that could be totally integrated in the design of the bike. To avoid the bike being stolen, the lock is integrated in the handle bar which makes the bike useless if the lock is cracked by a thief. To prevent damage, the handle bar is rubber protected and a kickstand is used which makes the bike stand-up by itself. To facilitate storage of the bike, the handle bar can be removed and the "Downtownbike" becomes extremely small (8").

If necessary, the pedals can also be folded inward. The lighting system on a common bike is very likely to get damaged easily, but it is also required for safety. Therefore, the light is integrated in the frame. The cargo problem is addressed with a specially designed bag which can be both used as a backpack or mounted as storage space in front of the bike. Connecting the cargo to the frame and not the steering construction makes the bike an excellent driving experience without stress.

7 SCOTT ROBERTSON.

"Bicycle design has been one of the highlights of my career so far. I think it is special to me because, not only I did ride a lot growing up in Oregon, but it was also my first professional design job. I landed an internship at Kestrel Bicycles in 1989, where I worked for one summer, and then continued to freelance off and on for over a decade.

The thing I like the most about designing a bicycle is that it is a product I can feel good about it. It is rare that you will ever see a Kestrel in a landfill. Bicycles promote health for the rider and for the environment when they are used by cycling commuters. When I first started to work on bicycle designs, I did not know how to render in Photoshop and most of my time was spent doing traditional drafting at a drafting board and in the shop with the pattern makers. I would take my one-to-one scale drawings and build the frame designs in wood to best illustrate my design ideas.

After studying many bicycle photographs and having come to better understand reflections and material indication myself while teaching in Switzerland, I developed the rendering techniques for the following images. These renderings are not rocket science, in fact they are simple to do and are based on the basic physics of reflectivity and how the human brain interprets form through value change. By utilizing the powerful layering techniques in Photoshop, an industrial designer's product vision can effectively come to life as an illusion of the product as it might be seen in a cleverly staged product photograph. The designs selected here represent the fanciful side of bike design. I hope you enjoy them."

7 "SPLINTERBIKE".
MICHAEL THOMPSON

"The challenge was to design and build a 100% wooden bicycle. 'No bolts or screws, just wood and glues' were the rules of engagement. This required taking a sideways look to overcome the many challenges in producing a rideable wooden bike. Obvious problems, like the chain, have been tackled by connecting the power from the pedals to the rear wheel by the simple addition of a gear cog (pliCog). This, however, took many hours to be designed and make the prototype.

The "SplinterBike" project came about after a casual £1 bet turned serious. Inspiration came from many areas but the most significant was the influence of the carbon-fibre "Lotus 108" time trial bicycle designed by fellow Norfolk designer Mike Burrows and made by the Norfolk based Lotus car manufacturer.

Just because the things around us are as they are, doesn't mean they have to stay that way. Alternatives can be designed for everything we use day to day and take for granted. We don't have to reinvent the wheel but it's interesting to try.

The "SplinterBike" forced me to employ timbers previously unused in my workshop such as "Lignum Vitae", a naturally self-lubricating hardwood, which is included for bushings and bearings to minimize friction where one component turns in an opposite direction to another.

Many years of woodworking experience has enabled me to make a bet with a friend and end up developing something that will ultimately set a land speed record for wooden bicycles. It's a testament to the versatility and strength of one of mankind's oldest available materials ... and of course, modern glue technology.

The "SplinterBike" took around 1,000 hours to be designed and constructed in a rammed earth garden shed in Norfolk, England."

7 "SUITCASE BIKE".
GOSHA GALITSKY

"My name is Gosha Galitsky. I am an Israeli industrial designer, currently operating in Sweden.

I have received my B.A. in industrial design from the "Bezalel Academy of Art and Design" in Jerusalem. I have worked in Europe and Israel for several years designing consumer products, home appliances, and medical equipment. Recently, I have been studying towards M.A. in product design at "Umea Institute of Design" in Sweden.

The "Suitcase Bike" is an innovative folding bicycle designed to operate seamlessly with public transport. Public carriers are well equipped to deal with luggage, and the folded "Suitcase Bike" becomes exactly that – a wheeled suitcase.

Most folding bicycles, even when folded are still cumbersome and difficult to carry. The "Suitcase Bike" folds into a package which encloses all the delicate and greasy parts. The folded bike can be easily rolled along on the front wheel.

The design process of the "Suitcase Bike" started in 2006 with almost 200 sketches, strength mock-ups and a working prototype.

The publication of the "Suitcase Bike" concept has triggered a lot of positive responses. A prototype of a new and improved version of the "Suitcase Bike" has been recently built and patented and a production version is scheduled to be unveiled soon."

7 TEAM TENTAKULUS.
SVEN FISCHER & JENS ROHDENBURG

"11Bikes" is exclusive, head-twisting bicycle frames with eyebrow-raising designs. The designs are limited to eleven pieces worldwide. Each frame is lovingly crafted by hand.

First bike: "Shocker Chopper" rocks and will for sure be an eye-catcher. Pure, simple and plain without much ado.

"11Bikes" is a project of "Team Tentakulus" and owners are Jens Rohdenburg and Sven Fischer. They design custom bikes that are hand-crafted and somewhat beyond ordinary. "Team Tentakulus" is an agency for interior and industrial design. Together with the "Team Tentakulus" network it is a platform for design. Their focus is on creative services. Flexible design consulting guarantees extraordinary interior and industrial design based on their interdisciplinary brain pool. They develop innovative concepts and offer extensive project management.

Facts: colour: Bluegrey, 8-speed coaster hub, Shimano Nexus with brake, Brooks lether saddle, double crown fork, massive 3″ wheels.

7 "WALDMEISTER".

Waldmeister The design of the "Waldmeister" is unique and absolutely new. The frame is designed without a seat tube, giving it some vertical flexibility. The two wooden arches have been calculated to optimally make use of the natural properties of wood, filtering vibrations out and giving the bike a pleasant, relaxed ride quality. The option to fit the attached parts to the customers' measures improves further the ergonomics of the bike. To make riding even more comfortable, the optional mountain gear integrated into the crank set allows the rider to climb steep mountains easily as well. The technically excellent design is matched by an equally special appearance. The noticeably high quality of the surface is achieved by applying several layers of veneer, giving the smooth surface a special gloss. For a bike, the design has been kept very clear and pure. Freed of the static seat tube normally found in a bike, the "Waldmeister" obtains a special kind of aesthetics. Like a predator ready to pounce, the "Waldmeister" radiates immense dynamics with a mysterious aura of easiness.

7 "ANT WOOD BIKE" & "ANT TRUSS BIKE".
MIKE FLANIGAN

"Ant" is a small bicycle fabrication shop, building bicycles for transportation and also makes antique style bicycles. Mike Flanigan has been in the bicycle trade since 1983 and began in the bicycle frame building business in 1989. Mike worked for "Fat City Cycles" from 1989 to 1994, then went on to help start the business "Independent Fabrication". Both of these companies made sporting mountain and road bicycles. Mike founded "Ant" so he could concentrate on creating bicycles for transportation that had an antique look. "Ant" designs were inspired by photographs of bicycles made during the 1890s.

One of Mike's dreams was to build a wood bicycle, like the Chilion Bicycle made in 1896 by the M.D. Stebbins Company in Springfield, Massachusetts, U.S.A. Mike made this wood bike for the "North American Hand-made Bicycle Show" in San Jose, California, in 2006. The wood bike was made from hickory wood blocks turned on a lathe. The frame lugs were welded from steel, carved into shape, then copper coated. The components were also copper plated and built into wood rims. The "Truss" bike was inspired by the frames built by Iver Johnson of "Fitchburg" Massachusetts, U.S.A. Iver Johnson was noted for his "Truss" frame bike and the durability for the rough roads of the 1900s, and he was also a gun manufacturer. Iver Johnson made bicycles up until 1941.

7 "FIREBIKES".

"'Firebikes' started in 1998. The first production frame was a BMX prototype. Then, a few years later, I saw a cruiser bike and I thought, 'Cool, but anyone can have one' as it was mass produced. So I decided to build my own. Well, the first bike was cool and people wanted one, so I made more and more, and soon they were worldwide. Since that date we have built one-off custom hand-made bikes and shipped them worldwide. Our bike frames continue to evolve and new designs always follow. We refuse to go overseas and because of this, you get a hand-crafted, one of a kind piece of art, one that no one else will have exactly alike. Built for you the way you like."

Sam McKay

01 & 02: "The Fluid"
03: "Black Widow"
04: "The Rumruneer"

7 "FOX. GAO".
BAMBOO BIKE

"In Chinese culture bamboo represents 'gentle, principled, and modest'. Well-educated people (in ancient China that means the nobles or the officers), all like to use bamboo to make some useful things, like the Chinese writing brush, musical instruments etc.; it is a high class material. We are using bamboo poles and hempen fibre to make an eco-friendly bike, which is fantastic and durable for riding."

7 "FRETSCHE".
THOMAS NEESER

He is a 40 years old inventor and bicycle manufacturer. He is a graduate teacher of "Art and Design" and a trained mechanic. The "Three supporters of the grandparents" is given new life. A metamorphosis of a design object with biographical background. By a joyous game with the style (quote – exaggeration – modification – reduction), and unique frame shapes. The characteristic, expressive fragments of existing old three-speed bikes are available in a new form of targeted and additional tube to supplement. The result is a hybrid object, in which the old and new are adjacent to each other and equally represented in an honest way. Here, the known, perceived in a new context, irritates and fascinates equally. Old and new merge into an entrancing whole.

The defined design principles, which developed technology and focus, confer on the recycling of local producers' products of a selected era of range of their homogeneous appearance. On the one hand, the developed bicycles shall constitute separate products, and on the other hand, they are objects that incite awareness to build them by yourself.

A work with broad span in the tension between design, art, mediation and recycling precious … the product design, which also questioned the conventional understanding of recycling. Much of the high-quality original product is unchanged in a new, hybrid integrated form. The result is a technically good as new object. Time traces. An exploration of the possibilities of how far the reallocation of labour effort and resources used could be gone. A recycled product in the precious sector.

Bikes in the pictures are made from participants in working classes that Neeser organizes annually. Every year Neeser and about twenty students build bikes.
Photo portrait: "Atelier Course Partitipants"
01: "Apollo 15". Bicycle made by Fretsche's student F. Schultz
02: "Tantur". Bicycle made by Fretsche's student, T. Aebersold
03: "Triemli". Bicycle made by Fretsche
04: "Bubentraum". Bicycle made by Fretsche
05: "The Jag Bicycle". Bicycle made by Fretsche's student, M. Feusi

IGOR RAVBAR

"My name is Igor Ravbar. I was born in 1962. Ever since my youth I have been working with wood. First, I was making wooden sculptures and later I was focused more on design in wood. I made a few wooden boats (a kayak and a canoe), and, in 2002, I made my first wooden bike "Woo 1". I make bicycles by combining my technical skills (as a mechanical engineer) and my knowledge of wood design."

01 & 02: "Men's City Bike". Made in 2002 of spruce strips and beech veneer. The inside of some wooden parts is reinforced with metal parts.
03: "Ladies City Bike". Made in 2004 of spruce and beech laminated veneer.
04: "Recumbent Bike". Made in 2003 of spruce strips. The two-piece chain drive is hidden in the wooden frame.

KEVIN CYR.

"The "Camper Bike" and the "Little Tag Along" are sculptural pieces that seek to explore aspects of mobility, shelter, and autonomy, and are emblematic of self-reliance and human perseverance. None of those two projects aims to provide a real life solution to social and environmental issues by claiming to be a real object. They are instead a reaction to materialism and excess as well as a comment on the current economic environment. The recent downturn has forced many people to make do with less. The spirit of frugality is something that we often embrace after it becomes a necessity, but can be liberating nonetheless. Both pieces also exemplify nostalgic impulses. "The Camper Bike" and "Little Tag Along" are equipped with items from the 1980s, a period in my childhood when camping was a frequent family activity. Biking has also been an important aspect of my life and has become the starting point for both projects. Both sculptures are stocked with camping stoves, cast iron skillets, lanterns, coolers, drinking containers, knives, and hatchets – all supplies to ensure a basic level of comfort and style."

7 "THE SNOWBOARD BIKE".
MICHAEL KILLIAN

"Human balance is detected in the inner ear. There are three semi-circular canals positioned at right angles to each other that detect balance in three axes. These canals are separate and distinct. The three types of balance are "Left to Right", "Front to Back" and "Rotational (Yaw)". "Left to Right" balance is what people are most familiar with and it is the primary balance used for riding a regular bicycle or indeed flying a plane. In the case of flying a plane there is a visual supplement to "Left to Right" balance provided by the observation of the horizon line. "Front to Back" balance has very little visual input and is the primary balance used for riding a surfboard or a snowboard. "Front to Back" balance is a finer instrument than "Left to Right" balance and offers a greater degree of artistic feedback. This is evidenced by the difference between skiing and snowboarding. Skiing ("Left to Right" balance) is faster than snowboarding ("Front to Back" balance); however, people like to snowboard because of the greater artistic expression. Here, I am introducing you a "Snowboard Bicycle" or "Snowboard Stance Bicycle" invented by myself, Michael Killian. This bicycle is ridden sideways and is balanced by using human "Front to Back" balance. It uses "Front and Rear Steering"."

7 "ORIGINAL SCRAPER BIKES"

""The Scraper Bike Movement" seeks to capture the creativity of youth living within dangerous communities. It gives them a positive outlet that is fun, educational and promotes healthy lifestyles. The "Scraper Bike Movement" offers youth a sustainable group of peers that is positive and motivating. We want to expand and enlighten young people's perspective on life through fixing and painting bicycles. Our goal is to support youth entrepreneurship and cultural innovation."

All images © Matthew Reamer

7 "STALK BICYCLES".
ZACK JIANG

STALK BICYCLES

"Our roots began in Beijing, originally as a green art project to inspire sustainable design in China. The concept was simple, to combine China's most abundant plant and its most utilized vehicle, the bicycle. While the project was short-lived, the seed was planted. "Stalk Bicycles" was born. Fast forward to today, here in Oakland, California. We are a team of passionate dudes dedicated to the lifestyle of two-wheeled transportation. In our pursuit of the perfect bike, we choose to build with bamboo – a material that is sustainable, surprisingly versatile, and can be sculpted to beautiful proportions. Whether rolling down a San Francisco alleyway, parked at a cafe in "The Mission", or hanging from a "Muni" bike rack, our bicycles stand out for their attention to detail, craftsmanship and unforgettable aesthetic.

We have no illusions of changing the world. But our feeling is that each of us, as individuals, can contribute to some extent to make the world a better place. "Stalk Bicycles" is our humble contribution."

VANHOU.

"'Vanhulsteinjn' is a Dutch company that consists of a small team of craftsmen. We try to create high quality bikes for riding with style. We produce our own bike designs in our own shop so we can make adjustments whenever necessary and build them just the way we like them. The mix of design and craftsmanship makes it possible to give each bike a personal character.

The latest result of our efforts is the "Cyclone". A beautiful head-turner that is designed for fast, comfortable rides. The frame is completely hand-crafted out of stainless steel and can be suited with a wide variety of high quality parts. We like to work in close cooperation with our customers so that individual desires can be met."

7 DUANE FLATMO.

Duane Flatmo lives in the northern West Coast town of Eureka, California. He is a full time artist/muralist/sculptor and he has been creating "Kinetic Sculptures" for 30 years. These sculptures are marvels of engineering and compete in the annual "Kinetic Grand Championship". It's a three day, 42 miles, human powered, all terrain race through "Humboldt County" held every year on "Memorial Day" weekend at the end of May. These sculptures must be able to traverse over roads, mud, sand, and water while carrying all the gear on board at all times. The sculptures are judged in three categories ... engineering, art, and speed. Duane also brings these contraptions to "Burning Man" each year and has added propane fire breathing mechanics to them. They are equipped with fully articulated mechanical controls which bring the sculptures to life as they peddle down the highway. You may have also seen Flatmo when he competed on the first season of "Junkyard Wars" as the team captain of "Art Attack". The team, including his other kinetic buddies Ken Beidleman and June Moxon, went on to take second place while spending a whole month in London filming the series in 2001. Being an entertainer of different sorts, Flatmo is always thinking of new ideas of bringing recycled junk back to life.
You can check out his signature act of Maleguena as seen on "America's Got Talent", "The Tonight Show" with Jay Leno and "Late Night" with David Letterman.

01: Duane Flatmo in front of his 2011 fire breathing "Bottom Feeder"
02: "Kinetic Grand Championship" poster designed by Flatmo
03: The "Tin Pan Dragon" cruising Samoa Beach during the "2008 Kinetic Race"
04: Steel tubing armature for the "Bottom Feeder", 2010
05: Steel wheels constructed of steel with cable spokes and turnbuckles

06: The components for the wheel design. Spokes, turnbuckles and copper swedges
07: "The Extreme Makeover" powering through "Humboldt Bay", 2005
08: "The Armored Carp." My first adventure to "Burning Man" with my friend "Bob Thompson"
09: A beautiful burner posing in front of the Bottom Feeder, "Burning Man" celebration, 2010
10: An afternoon cruise at "Burning Man", "Metropolis", Black Rock City / USA, 2010

7 KRANK-BOOM-CLANK
KINETIC CONVEYANCES OF WHIMSY

Krank-Boom-Clank (K-B-C) is a kinetic industrial art collective located in Santa Rosa, California, consisting of David Farish, Skye Barnett and Clifford Hill.

"We build 'kinetic conveyances of whimsy' and other mutant rideable sculptures of bemusement and delight (a.k.a. 'Freak-Bikes').

The "Hennepin Crawler" was recently completed in time for "Burning Man 2008" and "The Great Hand-car Regatta 2008" (www.handcarregatta.com).

The "Crawler" is comprised largely of discarded lawn furniture, VW Bug parts and old bikes among other bits too numerous to mention. It represents a desire to meld alternative transportation innovation, human-powered kinetic sculpture, recycling of disparate pieces of functional garbage and the prankster's notion of absurdity and bewilderment on an unsuspecting public.

"Murray the Fish" was built using a wide variety of found and recycled items: used bikes, discarded truck wheels, scraps of drainage pipe, a hammock frame and a door knob. All these elements combine to create a new, more entertaining way to get around. Making the assemblages mobile makes for a more interactive experience as well, engaging an often unsuspecting public. These constructions are intended to bring awareness to alternative forms of transportation as well as to the potential for excitement in the repurposing of everyday materials."

01: Portrait: Clifford Hill. Photo © Clifford Hill, Sassy Monkey Media, 2010
02: "Hennepin Crawler Tracks". Photo © Clifford Hill, Sassy Monkey Media, 2010
03: "Murray The Fish". Photo © Clifford Hill, Sassy Monkey Media, 2010
04: "Factory". Photo © Clifford Hill, Sassy Monkey Media, 2010
05: "Factory". Photo © Terry Hankins, Looking Glass Images, 2010

7 "WHYMCYCLES".
PETER WM. WAGNER

Peter Wm. Wagner – the Wm. became Whymcycles – has been a cyclist since he taught himself at the age of four and he began building bikes around the age of ten. His first bike was a new 1958 black 24″ Schwinn Spitfire one-speed. He rode it until 1974, and then he replaced it with a $ 5 1950s Schwinn cruiser which he had stretched into a tandem. He cut it back to a single frame and still has it. He mastered riding backwards, standing on the frame, on the rear wheel for hundreds of meters and hands-free for miles. Two-, three- and four-seat tandems have followed tricycles with two rears or two fronts; quad-racycles, rear wheel drive, front wheel drive, including hand-cycles. Also highwheels, tallbikes, amphibious tandem tractors, velocipedes, recumbents, trailers and cycle trucks have been realized. His "Whymcycle" is actually chainless with rear axle offset 3″ - 5″, which bounces for propulsion.

Wagner has made 125 of these, three with 2' x 3' race car tires that are also amphibious. One of them is in the national bicycle museum of Korea. All his family rides, his wife, Jerri, included and trailers with car infant seats allow newborns to ride within days. Motored and electric cycles have become bikes and 4″ x 7' wheels have been included in his designs. Used bikes are his favourite source, as well as anything wheel-like and he enthusiastically assists friends and strangers alike in all kinds of projects and cycling design solutions.

Photo portrait: "Whymcycles" builder, Peter Wm. Wagner, 2007, ⓘ
01: Inset, Peter Wm. Wagner and son Sam, ride on "Hoosier Bouncer # 114", ⓘ
02: "Honorable Pirate Ship (HPS) Glory" steered by Laura Duncan Allen, ⓘ
03: Peter & Laura Duncan Allen on the "Choo Choo". Ventura, "California Kinetic Sculpture Race", 2005, ⓘ

8 EXTRA.

On the following pages we present you a mixed bike journey:
From the organizations trying to help through bicycles other people from other countries, bike ballet organizations trying to present new bike performance ideas to bike products for sale.

"CRITICAL MASS"
BICYCLING'S DEFIANT CELEBRATION

"Critical Mass" is the name given to self-organized, mass bike rides that began in San Francisco in 1992. The idea spread rapidly by word of mouth and later through the internet. "Critical Mass" rides have been recorded in over 400 cities worldwide, including Chicago, Sao Paulo, Milan, Mexico City, London, Tokyo and Toronto.

We live in a culture that has lost a sense of public life, and certainly has radically reduced public space. "Critical Mass" was from its inception about reclaiming and repurposing the public streets for more convivial and social uses than the normal car traffic, and expanding our public life. One of the main problems is that so many big cities across the world are totally dominated by capitalism and cars, and, as a result, many people don't find the time or have the space to do things they want. With less social space in cities, people are looking for alternatives – new social places to meet each other and new ways to travel. When "Critical Mass" started we didn't know that it would become such an important public space. "Critical Mass" is a chance for cyclists to meet in public, to reinhabit the city on a new basis, and to form relationships out of which new political initiatives might grow.

I've been on probably no less than 40 or 50 fantastic rides in San Francisco – it's a great city with so many enjoyable places to ride and so full of hills. What I like about "Critical Mass" is that you are always discovering new places, even if you think you know the city so well.

In San Francisco, where it first started, the "Critical Mass" doesn't have much of a political culture right now, but there are about 1,500 participants in each ride. They come for all kinds of reasons, some to party, some to make an ecological statement, and others to demonstrate the rights of cyclists to use the city streets. There is little advertising for the event, but we still attract new people to the rides, and of course there are always the old-timers who come to nearly every ride. It's frustrating to me that there's not more political culture and xerocracy [xerocracy = photocopies made by anyone with their ideas, art, and suggestions for the ride] and I look forward to a more engaging political culture in the future.

I believe that "Critical Mass" opens a door for people to think about public space and how to use it more effectively. "Critical Mass" can't change everything alone, but it is one step in the right direction. It helps shape the imaginations of many people across the world to think differently about transit and cities. Bicycling is a more sustainable method of getting around, and a social and fun alternative to the car. "Critical Mass" has changed not only the use of bicycles, but also many people's way of thinking about how they can use their public and social space.

Chris Carlsson
(One of the founders of the "Critical Mass" idea in 1992 in San Francisco and editor of the book "Critical Mass: Bicycling's Defiant Celebration", 2002), ①

Photo portrait: Illustration by JR Swanson
01: "Critical Mass", San Francisco / USA, May 2010.
Photo © Chris Carlsson
02-03: Illustration by JR Swanson

HEY!

GET OUT OF OUR WAY!

CRITICAL MASS
SAN FRANCISCO

8 "BICYCLE BALLET".

"Bicycle Ballet was born on a sunny Sunday afternoon on a low tide beach in Shoreham on the South Coast of England. On a recently acquired bike, creative producer, Karen Poley, was cycling in circles, tracing bike wheel patterns in the wet, sunset sand and dreaming up a crazy idea …

Since that halcyon moment, the project has grown to include three touring, outdoor dance performances and a visual art installation project involving over 20 artists, performers and creators.

The shows are exhilarating, outdoor dance performances, which exude energy and positivity in celebration of cycling, even the gritty, nasty bits. They're made to draw in as wide an audience as possible, with fast paced and stunning choreography, striking imagery, spectacle and tricks, comedy and downright silliness.

"Throughout" the project, we've been lucky enough to have the support of the "Tru Thoughts" record label, whose funky beats are interwoven with interviews of the public, participants and performers talking about their bikes and cycling experiences, have become part of our trademark.

Outdoor work, and work which involves and engages people, are also a big inspiration. It still feels almost revolutionary to show work to the public for free, and even better to make people laugh and wince and enjoy art works they might never go to an indoor venue to see. We just hope the work will continue to sustain us, and our audiences, through and beyond the current economic situation."

All photos © Ray Gibson
01: "Bicycle Ballet Mass Show"
02-04: "The Dance of Cycling"

8 "GOODWILL".

Australian Goodwill Bicycles Abroad Inc. recycles unwanted bicycles in Australia as an option to dumping as landfill. AGBA collects, repairs, and stores donated bicycles and redistributes to those in need. Containers are loaded with bicycles and training in bicycle mechanics is provided within Australia and Developing Countries.

"A Bike called Barney" – a story about a bicycle.

"Just like any new bicycle, I was very popular. I was shiny, fresh, oiled and a loved part of the family, bringing joy to young and old alike, with many happy faces riding me down the street.

But as the years went by, my pretty paint had faded and age began to show as the rust set in. Soon, I realized I was no longer so popular, especially when a new bike took my favourite place in the shed. After that, I was treated just like a piece of metal, with little worth at all. No one cared for me anymore, no oil, no rides, and my seat was always cold.

Then, one day, a new face appeared to save me from a life of gloom. After a short time of riding me, a tire burst and thus my fate was sealed.

Late one night, I was taken to the bridge in Ballina, New South Wales, and thrown to my watery grave. Alone for years, I lay in the depths, cold, with only fish and crabs for company. My body was covered in shells, crustaceans and algae.

As chance would have it, one low tide, a man pulled me from my watery grave and restored me back to life. A new chain, two wheels and a little oil and off we went riding up River Street, life renewed. What was even more strange, as it may seem, I am more popular now than when I was brand new."

This bike demonstrates how the most neglected and unwanted bike can be put to practical use. In other words, no matter what condition a bicycle is in, it can be restored.

Mark Pate – Founding Director

8 KARA GINTHER.

To leather artisan Kara Ginther, utility and beauty often mean the same thing. Ginther finds great delight in incorporating beautiful objects into everyday tasks. She wants people to interact intimately with her art, even if it means sitting on it.

Ginther's work is very time-consuming and tedious. Using fine wood-carving tools, she carves into the leather, removing the thinnest layer to reveal contrasting colour and texture. She gets much of her inspiration from the past: ancient textiles, antique tile patterns, and old world maps.

The already beautiful "Brooks" saddle serves as an ideal canvas for Ginther to display her love for pattern. Ginther's work allows her to offer yet another way for cyclists to display their unique personalities through their bikes. She is thrilled that her work can serve to support a movement toward a slow and simple lifestyle.

01: "Evolve". Adapted from MC Escher's "Sky and Water"
02: "Byzantine"
03: "Damask"
04: "Artifact"
05: "A Happy Trio"

DANIELLE BASKIN.

"Since starting painting helmets back in 2009 (originally as a means to get myself and friends to wear a helmet en route to college), I have found a wonderful place to thrive as a small business. In New York, I am surrounded by a strong-rolling bike community. There are tons of group rides, bike-related street festivals in all different boroughs, and alternative transportation organizations spreading buzz about the possibility of opening up our streets to bike share programs: all of these things are bringing the bicycle back to life! I feel like I am a part of the shift in the history of transportation. Using fashion and personal-customization in the era of Internet and the DIY craft movement can help introduce bicycles to new audiences and make them more mainstream. Besides thinking about a world where we can get along fine without automobiles, I really love working with paint on not-so-flat surfaces ... With some acrylics, ink, and polyurethane, helmets can be transformed into mobile advertising space or a place to share an image with the world on wheels. There are so many design possibilities ... I am particularly excited about the series based on a deck of tarot cards."

01: "Solar System Helmet"
02: "The Hermit Tarot Card Helmet"
03: "Red Apple Helmet"
04: "Sunset Helmet"
05: "Phrenology Chart Helmet"
06: "Mahogany Helmet"

8 "FELVARROM".

"The team of "felvarrom.com" or simply "Felvarrom" (meaning 'I will stitch it up') met some time around the middle of 2008. Its members are Péter Szabó, Márton Lakatos and László Szabó. From the cooperation of these three, from the directed chaos of their thoughts and hands, came "Felvarrom". If we have to say something about the goal: we want to represent our own graphic craze within the emerging (and border-breaking) subculture of cyclists. We see a new lifestyle unfold bearing nature in mind. Recycling objects and valuing high-quality, sensibly designed, good-working tools (that are, dare say, even beautiful) are the ideas to which not only cyclists subscribe to. Our other goal, just to say, is cycling. We are convinced that the increasing number of cyclists is the realistic alternative to the chaos in traffic of both big and small cities. We believe in the culture of cycling: the knowledge of and mutual adherence to the traffic code, good bikes and top gear. Think, recycle, act, change – that's the message of our products. Cycling is cool."

8 "MONKEY LED".

The "Monkey Light" creates full colour digital art on your spinning bike wheel. The digital art is generative, morphing between thousands of combinations of patterns and colours. The lights have a dual purpose of making incredible art and helping cyclists stay visible at night. "Monkey Lectric" was founded by Dan Goldwater in 2007 to create a new class of bike lighting featuring cutting edge digital art and style – without sacrificing practicality. Dan was inspired to found the company based on the tremendous response to his custom art bikes as he rode them around the streets of Oakland and San Francisco.

INDEX
INFORMATION – ACKNOWLEDGEMENTS

INFO ARTISTS, ORGANIZATIONS & SUPPORTERS
URBAN ART

AEC. INTERSNI & KAZKI
AEC: interesni@li.ru / WAONE: waone_ik@yahoo.com
interesnikazki.blogspot.com

C215
c215@c215.com / www.c215.com

FALKO
tvafalko@hotmail.com / www.falko.co.za

FUNK25
funk25@gmx.net / www.myspace.com/funk_25

HOPNN
yuri_mail@libero.it / www.flickr.com/photos/yuriromagnoli

NESSE
nesseone@hotmail.com / www.rocadesud.com

SEX / EL NIÑO DE LAS PINTURAS
www.elninodelaspinturas.com

STINKFISH
eldulcehogar@gmail.com / www.stink.tk

TIKA
tika@gmx.ch / www.tikathek.com

MART
www.airesmart.com.ar

URBAN ART PUZZLE
3STEPS
mail@3Steps.de / www.3Steps.de

ALEX HORNEST
alexhornest@gmail.com / www.alexhornest.com

BESOK – DANIEL DOEBNER
besok@gmx.de / www.danieldoebner.de

BILL WRIGLEY
virgodawe@gmail.com / www.billwrigley.com

CERN
cernone@gmail.com

CIRO SCHU
ciroschu@uol.com.br / www.myspace.com/ciroschu
www.fotolog.com/ciroschu / www.flickr.com/photos/ciroschu

CISCOKSL
ciscoksl@gmail.com / www.ciscoksl.com

DAVE LOEWENSTEIN
dloewenstein@hotmail.com / www.davidloewenstein.com

DAVID GUINN
dgmurals@gmail.com / www.davidguinn.com

DRYPNZ
drypnz@drypnz.com / www.drypnz.com

ERIK BURKE
eriktburke@gmail.com / www.eriktburke.com

EXTRALARGOS
cadexl@hotmail.com

GUALICHO
soy@gualicho.cc / www.gualicho.cc

KATRE
contact@katre.fr / www.katre.fr

KENOR
jonasromero@hotmail.com / www.elkenor.com

LELO
joaolelo@gmail.com / www.flickr.com/photos/joaolelo

LIQEN
likenico@hotmail.com / www.liqen.blogspot.com

LIVE2
live2store@hotmail.com / www.live2store.com

LUDO
ludopiu@yahoo.it

MANDY VAN LEEUWEN
mandyvanleeuwen@hotmail.com / www.mandyvanleeuwen.com

MARCOS ANDRUCHAK
andruchak@yahoo.com.br / www.flickr.com/andruchak
www.flickr.com/artebrasil / www.andruchak.com.br

MONA CARON
mona@bok.net / www.monacaron.com

OS GEMEOS
fiz@uol.com.br / www.osgemeos.com.br

PAUL SANTOLERI
paulsantoleri@gmail.com / www.paulsantoleri.com

PENER
bswiatecki@wp.pl / www.city2city.pl

PETER DREW
hellopeterdrew@gmail.com / www.peterdrewarts.com

RYAN DINEEN
ryandineen.art@gmail.com / www.ryandineen.com

SABOTAJE AL MONTAJE
info@sabotajealmontaje.com / www.sabotajealmontaje.com

SEBASTIAN JAMES
www.sebjames.com

SPROUT PUBLIC ART
curt@sproutfund.org / www.sproutfund.org

VITCHE & JANA JOANA
vitche@vitche.com.br / www.vitche.com.br

WERC & CROL
werc305@gmail.com / www.laentradaproject.com
croler@gmail.com / www.crolvswerc.com

WOOZY / VAGGELIS CHOURSOGLOU
woozy_cd@hotmail.com / www.woozy.gr

ZBIOK
zbiokowsky@gmail.com / www.flickr.com/photos/zbiokosky

PAINTINGS
ADRIAN LANGKER
langkers@optusnet.com.au / adrianlangker.wordpress.com

ALISON GAYNE
artagayne@gmail.com / www.alisongayne.com

BORIS INDRIKOV
boris@indrikov.com / www.indrikov.com

BRIAN D. CUMMING, photographer
www.bdarcimages.com

CATHERINE MACKEY
catherine@catherinemackey.com / www.catherinemackey.com

DARIO PEGORETTI
info@pegoretticicli.com / www.pegoretticicli.com

ETOE
info@etoe.de / www.etoe.de
MARTIN JAHNECKE, photographer

HOKE HORNER
nikkihoke.blogspot.com

JAMES STRAFFON
info@james-straffon.co.uk / www.james-straffon.co.uk

JEFF PARR
info@jeffparr-veloart.com / www.jeffparr-veloart.com

JERRY WAESE
jerry@jerrywaese.ca / www.flickr.com/people/waese

JIMMY ABROBERTS AND BRIAN CHRISTOPHER
info@jabcstudio.com / www.jabcstudio.com

KEVIN NIERMAN
me@kevinnierman.com / www.kevinnierman.com
skiptooth.blogspot.com

KO MASUDA
ko5@heteml.jp / www.ko5.jp
www.komasuda.exblog.jp

LINDA APPLE
apple@applearts.com / www.applearts.com

LOU READE
lou.m.reade@gmail.com / www.loureade.co.uk

LUMA BESPOKE / PETER LIN
peter@luma-bespoke.com / www.luma-bespoke.com

MR KERN
dieulafe@gmail.com / www.mrkern.com
ornaldokern.blogspot.com

"MWM GRAPHICS" / MATT W. MOORE
mwmgraphics.blogspot.com / www.mwmgraphics.com / www.glyphcue.com

PETER J. KUDLATA
www.arthouse-studio.com

SHERRI DAHL
sherri_dahl@hotmail.com / www.flickr.com/accumulatedobjects

STEVE DENNIS
steve@velopaint.com / www.velopaint.com
www.velopaint.blogspot.com

DAVID ETTINGER, photographer
www.davidettinger.photoshelter.com

TALIAH LEMPERT
taliah@bicyclepaintings.com / www.bicyclepaintings.com

TIAGO DE JERK
dejerk@gmail.com / www.dejerk.com
WILLIAM BEBOUT, photographer
JONATHAN MAUS / www.bikeportland.org

PAINTINGS PUZZLE
2501
ceccarelliiacopo@hotmail.com / www.flickr.com/photos/never2501

ALISON ELIZABETH TAYLOR
www.jamescohan.com/artists/alison-elizabeth-taylor

ARYZ
www.aryz.es@gmail.com / www.aryz.es

DAVID DE LA MANO
daviddelamano@gmail.com / daviddelam.blogspot.com

JESSICA BRILLI
jbrilli@gmail.com / www.jessicabrilli.com

INSA
info@insaland.com / www.insaland.com

KLAAS LAGEWEB
info@klaaslageweg.com / www.klaaslageweg.com

MARK SKULLS
mskulls@gmail.com / www.markskulls.com

MICHAEL CHEVAL
mkcheval@gmail.com / www.chevalfineart.com

MR WANY
info@aleandrew.com / www.aleandrew.com

OKUDA
okudaps@hotmail.com / www.okudart.es

OTHER
troy.lovegates@gmail.com / www.flickr.com/photos/other

STOHEAD
stohead@stohead.de / www.stohead.de

STORMIE MILLS
stormie@magenta.net.au / www.stormiemills.com

WILLIAM LAZOS
wlazos@hotmail.com / www.williamlazos.com

ZONENKINDER / Caro & Phil
zonenkinder@gmx.net / www.zonenkinder.de.be
www.zonenkindercollective.de.vu

ILLUSTRATIONS – DRAWINGS
ADAM TURMAN
adam@adamturman.com / www.adamturman.com
www.facebook.com/Adam.Turman

ADAMS CARVALHO
ffffixas@gmail.com / www.ffffixas.tumblr.com

ALAIN DELORME
contact@alaindelorme.com / www.alaindelorme.com

ANDY SINGER
andy@andysinger.com / www.andysinger.com

BLANCA GOMEZ
info@cosasminimas.com / www.cosasminimas.com

CHRIS KOELLE
chriskoelle@gmail.com / www.christopherkoelle.com
sweetride.etsy.com

CHRIS PIASCIK
chrispiascik@gmail.com / www.chrispiascik.com

CHRIS WATSON
chris@chris-watson.co.uk / www.chris-watson.cc

"COG" Magazine
info@cogmag.com / www.cogmag.com

"CRICKET PRESS" / BRIAN TURNER
cricketpress@gmail.com / www.cricket-press.com

DAMARA KAMINECKI
damarak@aol.com / www.damarakthedestroyer.com

DAVID PINTOR
davidpintor1975@yahoo.es / www.davidpintor.blogspot.com

EMILIO SANTOYO
hiemilio@gmail.com / www.emiliospocket.com

FIRST FLOOR UNDER
www.firstfloorunder.com

FRANCIS KMIECIK
franciskmiecik@gmail.com / www.halfanese.com

HUGH D'ANDRADE
hugh@hughillustration.com / www.hughillustration.com

IAN HOFFMAN
thehoffmanian@gmail.com / www.hoffmanian.ca
www.processhaus.com

ILOVEDUST
hello@ilovedust.com / www.ilovedust.com

JAMES GULLIVER HANCOCK
james@jamesgulliverhancock.com / www.jamesgulliverhancock.com

JANET BIKE GIRL
janetbikegirl@yahoo.ca
www.flickr.com/photos/janetbikegirl

JAY RYAN
posters@thebirdmachine.com / www.thebirdmachine.com

JENNIFER DAVIS
jenniferdavisart@gmail.com
www.jenniferdavisart.blogspot.com / www.jenniferdavisart.com

JESSICA FINDLEY
j@sonicribbon.com / www.jessicafindley.com
www.sonicribbon.com / aeolian-ride.info

KEN AVIDOR
mail@avidorstudios.com / www.roadkillbill.com
bicyclopolis.blogspot.com / postcarboncomics.blogspot.com

KRISTA TIMBERLAKE
kstlake@hotmail.com / www.kristatimberlake.com

MADS BERG
mail@madsberg.dk / www.madsberg.dk

MIKE GIANT
www.mikegiant.com / www.rebel8.com

MONA CARON
mona@bok.net / www.monacaron.com

MONSIEUR QUI
mrqui@free.fr / www.monsieurqui.com

NATE WILLIAMS
art@magnetreps.com / www.magnetreps.com

PAT PERRY
www.patperry.net

REMEDIOS
info@latiendaderemedios.com / www.latiendaderemedios.com

RICCARDO GUASCO
guasco.riccardo@gmail.com / www.riccardoguasco.com
www.mumblerik.blogspot.com

RUSL
rusl@bicyclefamily.ca / www.rusl.ca

SHORTYFATZ / SAMUEL RODRIGUEZ
shortyfatz1@gmail.com / www.shortyfatz.com

"THE RIDE" / ANDREW DIPROSE, art director
www.theridejournal.com

WILL MANVILLE
willmanville@gmail.com / www.willmanville.com

ILLUSTRATIONS – DRAWINGS PUZZLE
ALEKSEI BITSKOFF
alex.bitskoff@gmail.com / bitskoff.blogspot.com

ALEXANDER POMPEYA
cristiancancinomoreno@gmail.com

DENNIS BROWN
bagger43@gmail.com / www.bagger43.com
bagsbrown.blogspot.com

DIRK PETZOLD / DIRK PETZOLD HANDELS & MEDIENAGENTUR
www.dp-illustrations.com

EVAN B. HARRIS
evan@evanbharris.com / www.evanbharris.com

FLYING FÖRTRESS
fortress@rockawaybear.com

GERA LUZ
geralozano@gmail.com / www.geralozano.com

H. VENG SMITH aka VENG
veng@robotswillkill.com / www.vengpaintings.com

HUEBUCKET
hihue@huebucket.com / www.huebucket.com

JEREMY SLAGLE / JEREMY SLAGLE GRAPHIC DESIGN
Jeremy@jeremyslagle.com / www.jeremyslagle.com

JONAH BIRNS
jonah.birns@gmail.com / www.redhookcrit.com
ERIK LEE SNYDER, CASEY KELBAUGH & DAVID TRIMBLE, photographers

JOSUE MENJIVAR
josue64@shaw.ca / www.freshbrewedillustration.com

LAHE
ana.langeheldt@gmail.com / www.laheworks.com

LEANDRO CASTELAO
info@leandrocastelao.com.ar / www.leandrocastelao.com.ar
www.postercabaret.com

LIFTER BARON
info@lifterbaron.com / www.lifterbaron.com

MATT OXBORROW
matt@mattoxborrow.co.uk / www.mattoxborrow.co.uk

MIA NILSSON
mia@mianilsson.com / www.mianilsson.com

NEUZZ
neuzz@live.com.mx

SAME84
same_oner@hotmail.com / same84.blogspot.com
www.same84.com

SEAN KANE
sean@seankane.com / www.seankane.com

SERGIO GOMEZ CABALLERO
info@srger.com / www.srger.com

SICKSYSTEMS
info@sicksystems.ru / www.sicksystems.ru

TIM DOYLE
tim@nakatomiinc.com / www.NakatomiInc.com

TATTOOS
ABT
Todo1@ABTTattoo.com / www.abttattoo.com

ANDY BARRETT
andy@tattooandy.com
www.horseshoesandhandgrenadestattoo.com

BRASS MONKEY TATTOO STUDIO / GARY BIELBY
brassmonkeytattoo@hotmail.com
www.checkoutmyink.com/profile/brassmonkeytattoo

EROSIE
erosie.net@gmail.com / www.erosie.net
Tattoo artist: Lil'd, East Atlanta / USA.
Tattoo owner and photo © Matt Pensworth
www.flickr.com/people/pseudothoughts

JAIME MARIEL W.
www.flickr.com/photos/26215062@N06

JEREMY SWAN / BROKEN ART TATTOO
swan@brokenarttattoo.com / www.brokenarttattoo.com

KORI
korianderspice@gmail.com

KURT RAMPTON
krautstache@gmail.com / www.krautstache.com

MICHAEL CLEVELAND
wunnspeed@gmail.com / www.wunnspeed.wordpress.com
www.flickr.com/photos/wunnspeed

MIGUEL ANGELO
info@miguelangeltattoo.com / www.miguelangeltattoo.com

MICAEL TATTOO
micael@micaeltattoo.com.br / www.micaeltattoo.com.br

OLIVIA / SACRED ART TATTOO
www.sacredarttattoo.co.uk
NORTHWEST, photographer
www.northwestisbest.co.uk
Tattoo owner: Vicky Richardosn

SAKE TATTOO
saketattoo@gmail.com / www.saketattoo.com

TEE JAY / WHITE TIGER TATTOO
teejay@whitetigertattoo.com / www.whitetigertattoo.com

SCULPTURES
ALASDAIR NICOL
al@tendril.net.au / www.alasdairnicol.com

WILF IUNN
postmaster@wilflunn.com / www.wilflunn.com

CARO
caro@kein.org / www.facaro.com

MATT CARTWRIGHT
info@cartwrightdesign.com / www.cartwrightdesign.com

DAVID GERSTEIN
david@davidgerstein.com / www.davidgerstein.com

DEREK KINZETT
derekkinzett@hotmail.co.uk / www.derekkinzettwiresculpture.co.uk

JOE GAGNEPAIN
artbyjoseph@yahoo.com / www.artbyjoseph.com

DZINE
d@dzinestudio.com / www.dzinestudio.com

MARK GRIEVE & ILANA SPECTOR
markdgrieve@gmail.com, ilanaspector@gmail.com
www.markgrieve.com
DAVID HAINES, photographer
www.bikeranger.com

OLEK
olekinfo@gmail.com / www.agataolek.com
www.vimeo.com/18306137 / www.vimeo.com/20993358

TYPES
"AZOR" / KONSTANTIN DATZ
hallo@konstantindatz.de / www.konstantindatz.de
www.behance.net/konstantindatz

"BIKE 2.0" / INODA SVEJE
info@inodasveje.com / www.inodasveje.com

"BME DESIGN" / "ONEYBIKE" & "FAJNYJE2" / PETER VARGA
petov@petovdesign.com / www.petovdesign.com

BRANO MERES
mail@bmeres.com / www.bmeres.com

"CARBONWOOD" / GARY GALEGO
mail@garygalego.com / www.garygalego.com

"ECO//7" / VICTOR ALEMAN
info@victoraleman.mx / www.victoraleman.mx

"GREEN SHADOW" / OSÉ MARÍA PARRA SÁNCHEZ
info@onuff.com / www.onuff.com

"HIDEMAX" / SERVET YUKSEL
servetyuksel@gmail.com / www.servetyuksel.com

"HMK 561" / RALF KITTMANN
mail@ralfkittmann.de / www.ralfkittmann.de

"IBIKE" / REINDY ALLENDRA
industrial_ndysign@yahoo.com / www.allendra.carbonmade.com
www.behance.net/miradesign / www.coroflot.com/oddesign

"KTM X-STREET" / CHARLES-EDOUARD BERCHE
charli.berche@hotmail.fr

"LOCUST" / JOSEF CADEK
contact@josef-cadek.com / www.cadekdesign.com

"NULLA" / BRADFORD WAUGH
bradfordwaugh@gmail.com / www.bradfordwaughdesign.com

"OKES" / REINIER KORSTANJE
info@reinierkorstanje.nl / www.reinierkorstanje.nl

"ORYX" / HARALD CRAMER
harald.cramer@gmx.net / www.haraldcramer.de

RAFAEL GEORG SCHMIDT
info@rafaa.ch / www.rafaa.ch

"SANDWICHBIKE & DOWNTOWNBIKE" / BLEIJH
ite@bleijh.com / www.bleijh.com

SCOTT ROBERTSON
www.drawthrough.com

"SPLIDERBIKE" / MICHAEL THOMPSON
thompson_norwich@hotmail.co.uk / www.splinterbike.co.uk

"SUITCASE BIKE" / GIOSHA GALITSKY
gosha_id@yahoo.com / www.coroflot.com/gosha_id

TEAM TENTAKULUS / SVEN FISCHER & JENS ROHDENBURG
sf@team-tentakulus.de / www.team-tentakulus.de

"WALDMEISTER"
info@waldmeister-bikes.de / www.waldmeister-bikes.de
CHRISTIAN ROKOSCH photographer

"ANT WOOD BIKE" & "ANT TRUSS BIKE" / MIKE FLANIGAN
antbikemike@gmail.com / www.antbikemike.com
www.antbikemike.wordpress.com

"FIREBIKES"
info@maydaybikes.com / www.firebikes.com

"FOX. GAO"
foxgao@chinakinsun.com / www.bammabicycle.com

"FRETSCHE" / THOMAS NEESER
info@fretsche.ch / www.fretsche.ch

IGOR RAVBAR
igor.ravbar@narmuz-lj.si

KEVIN CYR
kevin@kevincyr.net / www.kevincyr.net

"ORIGINAL SCRAPER BIKES"
www.originalscraperbikes.blogspot.com
MATTHEW REAMER, photographer
www.matthewreamer.com / yousayyes.wordpress.com

"STALK BICYCLES" / ZACK JIANC
zack@stalkbicycles.com / www.stalkbicycles.com

"THE SNOWBOARD BIKE" / MICHAEL KILLIAN
killianmichael@hotmail.com / www.sidewaysbike.com

VANHU
info@vanhulsteijn.com / www.vanhulsteijn.com

DUANE FLATMO
duane@duaneflatmo.com / www.duaneflatmo.com

KRANK-BOOM-CLANK – KINETIC CONVEYANCES OF WHIMSY
info@krankboomclank.com / www.krankboomclank.com

"WHYMCYCLES" / PETER WM. WAGNER
whymcycle@sbcglobal.net

EXTRA
"CRITICAL MASS": BICYCLING'S DEFIANT CELEBRATION
critmasssf@gmail.com / www.sfcriticalmass.org
CHRIS CARLSSON / www.nowtopians.com
www.shapingsf.org/Ten_Years_book.html

"BICYCLE BALLET"
KAREN POLEY, Creative Producer
bicycle_ballet@yahoo.co.uk / www.bicycleballet.co.uk

"GOODWILL"
MARK PATE, Managing Director
goodwill_bicycles@yahoo.com.au / www.goodwillbicycles.com
JENNIFER CLARKE & MARK PATE JENNY, photographers

KARA GINTHER
karaginther@gmail.com / www.karaginther.com

DANIELLE BASKIN
bellehelmets@gmail.com / www.bellehelmets.com

"FELVARROM"
info@felvarrom.hu / www.felvarrom.hu

"MONKEY LED" – DAN GOLDWATER
info@monkeylectric.com / www.monkeylectric.com

SUPPORTERS:
CARPE DIEM
carpediemact@gmail.com / www.carpe-diemact.gr
www.bikeart.gr

AEROSPOKE
www.aerospoke.com

PI MOBILITY
info@picycle.com / www.picycle.com

MBIKE
info@mbike.gr / www.mbike.gr / www.bikefestival.gr
COSMOS LAC – SABOTAZ80
info@sabotaz80.com / www.sabotaz80.com
finance@cosmoslac.com / www.cosmoslac.com

PHOTO INFOS
URBAN ART
Page 28:
01: Project "StadtRad Hamburg - On Your Mobile Canvas and Off You Go!"
The "StadtRad" ("city bike") was introduced in Hamburg some years ago. It is meant as an easy accessible network of bike rental outlets with unmanned stations spread all over Hamburg: "Experience all Hamburg has to offer, whether work, leisure or tourist attractions, in a very special way, right in tune with the pulse of the city." As we love riding a bike everyday, the bike rental outlets caught our eyes as soon as the first ones got installed and a fleet of red bikes started to conquer the streets of the city. Particularly the fabulous carrier-design that is perfect for sticking something on this surface! Thrilled by the idea of spreading our name and artworks via this means of transportation all over the city we decided to use the half-round rear end of the bicycle-carriers for our purposes: we started pasting stickers and hand-made posters on the bikes and still continue to do so. A lot of creative street-lovers join us now, spreading their message via the "StadtRad-bikes".
05: "The Duboce Bikeway Mural". Project celebrating bicycle riding and alternative transportation in San Francisco. Commissioned by "City of San Francisco Bike Program". Sponsored by the "San Francisco Bicycle Coalition". San Francisco / USA

URBAN ART PUZZLE
Page 36
06: Image: Hoscht from team "Vodkawasser",
www.knochenbruch.net. Photo © www.jenshogenkamp.com

ILLUSTRATIONS – DRAWINGS
Page 138:
01: "Lucas Brunelle". "Super-maniac" wouldn't really describe the riding and the messenger racing films that this madman does. Watercolour, 2010
02: "Francesca Tallone". Photographer and curator extraordinaire, rides the tiniest fixed bike I have seen. We are friends because of bikes and art. Francesca first fell in love with my inflatable bike art project "Aeolian Ride" and brought it out to Halifax. Watercolour, 2010
03: "Maki Hojo". Wins the dedication award. She likes a challenge and takes everything to its maximum potential. Some might say she could be the fastest female rider in Tokyo. Watercolour, 2010
04: "Sadek Bazaraa". An amazing artist and designer and magician that inspires the galaxies in me. Watercolour, 2010
05: "Jessica Findley". That's me. Part animal, part inflatable, mostly aeolian. Watercolour, 2010

Page 175:
04: "Spokes and Leaves". The work was made for and won the third prize in a competition for London transport in 2010. I wanted to show the health and environmental benefits of cycling as well as the opportunity to see sights of London that you wouldn't otherwise see.

TATTOOS
Page 182:
03: "BRASS MONKEY TATTOO STUDIO" / GARY BIELBY
"I studied Chinese painting and tattooing under my teacher 'Sun Bo', a well known tattooist. I studied fine art at "Manchester University of Art" in England, I am 29 years old and originally I came from England, but I have worked in China for five years."

SCULPTURES
Page 202:
"Crocheted Grapefruit" is made possible in part with public funds from the "Fund for Creative Communities". Supported by "New York State Council on the Arts" and administered by "Lower Manhattan Cultural Council". Special thanks to additional contributor Felicity Hogan.
Dev Harlan (www.devharlan.com) combined Olek's street bike idea with video projection mapping on a bike sculpture to create a completely new work.

TYPES
Page 221:
The bicycles are equipped with GPS and W-LAN, thus being able to inform the network system about their current position and status. An internet-based platform can analyze the different interests and then can manage possible conflicts. The bike is equipped with a supporting electric motor and a 26V lithium battery (E-bike) to make it suitable for short and long distances up to 15 km. The battery has a range of max. 50 km and is recharged at the stations. In order to prevent theft and damage, most of the components are integrated into the frame or the wheel. The LED lighting, for example, cannot be dismounted; drum brakes, generator and 8-speed gear are integrated into the hub. The bike combines usefulness with simple, modern elegance.
How to use a bike: To use a bike, you have to register on the Internet or insert a credit or Maestro card into the bike's handle bar and log in. The first 30 minutes are free; after that, 3 € per 30 minutes will be charged. The fee per hour rises proportionally to ensure that the bikes stay in circulation. There are stations everywhere in Copenhagen's city centre (max. distance 300 meters). At all times, you can find out on the Internet how many bikes are available at which stations. Commuters will be able to profit from a text message service informing them about available bikes. Train passengers will have the possibility to make a reservation 30 minutes in advance.

Page 241:
Photo portrait: "Whymcycles" builder, Peter Wm. Wagner, atop his highest tall-bike, the "Uber Tallie", built in one day, 2007
01: Inset, Peter Wm. Wagner and son Sam ride on "Hoosier Bouncer # 114", "Blue". Made in November 2005 from a scooter, with "Hoosier" sprint race car tires mounted on 1965 Volkswagen wheels. It is now in the "National Bicycle Museum of Korea", in Sangju, Korea.
02: "Honorable Pirate Ship (HPS)" glory steered by Laura Duncan Allen, descending the sand dune at the "2008 da Vinci Days Kinetic Sculpture Race" in Corvallis, Oregon. This machine has four wheels that are six feet tall and is piloted by five women.
03: Peter & Laura Duncan Allen on the "Choo Choo" on the beach after the water segment of the "2005 Ventura, CA Kinetic Sculpture Race". Along side are "Blaster and Kommander" built and piloted by Paul Vibrans, also "Captain Nemo Goes Surfing", piloted and built by Elliot Naess. All these machines are fully amphibious and solely people powered.

EXTRA
Page 244:
"Ten Years That Shook the City: San Francisco 1968-78". Edited by Chris Carlsson with LisaRuth Elliott. City Lights Publishers, June 2011. www.shapingsf.org/Ten_Years_book.html

WEB BIKE LINKS
Atomiczombie.com – antbikemike.wordpress.com
benbikes.org.za – bicycledesign.net – bicycleart.org
bicyclefilmfestival.com
bicycletutor.com – bicycledesign.net – bicycleman.com
bikecult.com – bikesandthecity.blogspot.com
bikeforall.net – bikemania.biz – bikesnotbombs.org
bikeportland.org – bikesfortheworld.org – bikewriterscollective.com bicyclemusicfestival.com – bikerodnkustom3.homestead.com
boneshakermag.com/stockists – bostonbiker.org – brushspoke.com
2-pedals.org – carbusters.org – cargocycling.org
chicagofreakbike.org – copenhagencyclechic.com
critical-mass.info – chopzone.com - cyclestyle.com.au
elcyclista.com – everydaycycling.com – ecovelo.info
hobartbikekitchen.org/about – ibiketo.ca – kinetickensington.org
lovingthebike.com/crank-directory – lovelybike.blogspot.com
lostateminor.com – lowriderbike.com – mobilityweek-europe.org
mycargobike.net – openstreetmpls.com – papergirl-berlin.de
postercabaret.com – recycleabicycle.org – re-cycle.org
recumbentblog.com – rockthebike.com – sfcriticalmass.org

streetfilms.org – sydneycyclechic.org
thebicycleworks.org – thecyclecoo.com – thebikeshow.net
thewheelmen.org – trackosaurusrex.com
wheelbike.blogspot.com – worldnakedbikeride.org – worldcarfree.net
yankodesign.com – urbanvelo.org – veloclassique.com
velorution.biz

WEB BIKE LINKS FROM GREECE
Acropolisbikes.gr – alitogatoi.blogspot.com – athensbybike.gr
athensfixedgear.com – athenssunbiker.blogspot.com
athensbikecourier.blogspot.com – bicyclelarissa.blogspot.com
bikeart.gr – bike2door.gr – bikefestival.gr – bikerespect.gr
bondexcouriers.com – bike-sharing-gr.blogspot.com
criticalmass.gr – cmheraklion.blogspot.com – cyclist-friends.gr
cyclistsofkalamata.blogspot.com – enosipezon.gr – filoi-podilatou.gr
localathens.blogspot.com – mbike.gr
podilates.gr – podilatis.com – podilatres.gr – podilatreis.gr
podilatesioannina.blogspot.com – podilatestrikalon.wordpress.com
podilato.gr – podilato.com.gr – podilates.tk -
podilatespatra.blogspot.com – podilates-thess.gr
podilatontas.blogspot.com – podilatada.blogspot.com
roadmovie.wordpress.com – streetpanthers.gr
worldnakedbikeride.gr – zoi-podilato.com

Acknowledgments

We would like to thank all those who supported this effort: Same84, Maria Barbatsi, Anna Morgenroth, Dorota Kostopoulou, all the artists and photographers, artists who helped us make contact to others, organizations for their participation, Krixl and Publikat Publishing family, our supporters: Carpe Diem, Michael and Aerospoke family, Marcus and PiMobility family, Thano, Lena and Red Bull, Spiro, Athina, Nassia and MBIKE family, Achilles and Sabotaz80 family and all of you, especially, for your trust and support.

publikat
PUBLISHING PROGRAM

http://www.stylefile.de
http://www.publikat.de

AFTER THE LAUGHTER
the 2nd book of herakut
11.2011
isbn 978-3-939566-36-6
jasmin siddiqui, falk lehmann
hardcover. 21 cm × 26 cm. 240 pages

HERAKUT
the perfect merge
04.2009
isbn 978-3-939566-24-3
jasmin siddiqui, falk lehmann
flexicover. 21 cm × 26 cm. 200 pages

THE ART OF REBELLION # 3
the book about streetart, for those who don't know
10.2010
isbn: 978-3-939566-29-8
c100
paperback. 21 cm × 26 cm. 216 pages

BANKSY
wall and piece
11.2006
isbn: 978-3-939566-09-0
banksy
paperback. 21 cm × 26 cm. 240 pages

MURAL ART # 3
murals on huge public surfaces around the world
11.2010
isbn:978-3-939566-28-1
kiriakos iosifidis
hardcover. 30 cm x 21 cm. 272 pages

MURAL ART # 2
murals on huge public surfaces around the world
11.2009
isbn: 978-3-939566-27-4
kiriakos iosifidis
hardcover. 30 cm × 21 cm. 272 pages

BACKFLASHES
graffiti tales
11.2009
isbn: 978-3-939566-21-2
ruedione
hardcover. 28 cm × 28 cm. 240 pages

MA'CLAIM
finest photorealistic graffiti
09.2006
isbn: 978-3-939566-01-4
steffen petermann, falk lehmann
paperback. 25 cm × 21 cm. 160 pages

INTERNATIONAL TOPSPRAYER
taps & moses
05.2011
isbn: 978-3-939566-35-9
ernie & bert
hardcover with flip image.
30 cm x 22 cm. 288 pages

ACTION PAINTING
bringing art to the trains
05.2009
isbn: 978-3-939566-25-0
kristian kutschera
paperback. 21 cm × 26,5 cm. 216 pages

STYLEFILE BLACKBOOK SESSION # 4
graffiti on paper, scribbles, outlines and full-color-stuff
07.2010
isbn: 978-3-939566-30-4
mike hefter, markus christl
paperback. 23 cm × 16 cm. 160 pages

STYLEFILE
graffiti magazine
out every march, july and november.
documenting in high quality the graffiti movement all over the planet.
for details and further information check
http://www.stylefile.de